HARWICH
Dovercourt and Parkeston

In Old Picture Postcards:
Volume 2

by

Phil Cowley

S.B. Publications

By the same author:
Harwich and Dovercourt
in Old Picture Postcards

To Sue, Lisa and Nick who, for many years, have endured my desire to go to postcard and antique fairs and shops wherever we happened to be.

First published in 2001 by S.B. Publications
19 Grove Road, Seaford, East Sussex BN25 1TP

©Copyright 2001 Phil Cowley

ISBN 1 85770 220 4

Typeset and designed by E.H. Graphics (01273) 515527

Printed and bound by MFP Design and Print
32 Thomas Street, Stretford, Manchester M32 0JT

CONTENTS

ACKNOWLEDGMENTS

To the staff of Harwich and Colchester Libraries who
have dealt with my never ending enquiries for newspaper
archive material with their good humour; to those many
people who have given me snippets of information; and to
Mary and Brian Stevens who allowed me to use three
cards from their collection for this book.

Front Cover: **LIGHTHOUSE AND JETTY, DOVERCOURT BEACH**

A very popular view taken from the causeway between the two lighthouses looking towards the
Phoenix Hotel on the left and the Retreat on the right. The swings of the Retreat can be seen in front
of the building. The Phoenix was destroyed by fire in 1914. In 1882, it was offered for sale - "A freehold
family and excursion hotel known as the Phoenix Hotel, with adjacent spacious dining/refreshment
hall called 'The Hall by the Sea'; also two enclosures of meadow land and 8 roomed cottages". It did
not sell and was withdrawn at the final bid of £120. Until moving to the Royal Oak, Harwich and
Parkeston Football Club played their games on the Phoenix Ground which was beyond the small huts
in the front, almost on the current site of the Sports Club.

INTRODUCTION

Picture postcards were not licensed in the U.K. until 1894. These early cards had a short message on the picture side and the address on the reverse. In 1902, postal regulations were changed so that the picture side could remain without a message and the reverse could be divided to allow a message and the recipient's address.

Publishers were quick to respond to these changes with numerous postcards being published depicting every subject imaginable. The years between 1902 and 1914 were known as the 'Golden Age of Postcards'. Millions of cards were published and collected satisfying the national craze for collecting picture postcards.

Many homes had postcard albums probably displayed in their living rooms. Many cards can be found today with the message 'another one for your collection'.

Local photographers were not slow to miss this opportunity to satisfy this craze and produced numerous local views and events, some published locally and others by the national publishers. Cards from the Entente studio of Mrs Owen, the cameras of J. A. Saunders, Steggles, Dowdy and Woodward exist and are regularly found in postcard fairs, but the most prolific come from the camera of the Wallis family. Frederick Wallis (1911-1924) had studios in Great Bentley, Great Oakley and Little Oakley. When he died in 1924 the business continued with his widow Mrs E. M. Wallis of Little Oakley and Upper Dovercourt continuing until 1930. Wherever there was something happening, a Wallis and their camera seemed to be there.

Since the publication of the first volume in 1992, many people have asked me to compile a second volume. It has taken me years to locate and research this second selection of postcards which have been chosen to represent a broad cross section depicting life in Harwich, Dovercourt and Parkeston during the first forty years of the twentieth century.

This book is not a history of the three towns during this period but aims to illustrate the social history of the area, how local people lived at that time and the buildings they lived and worked in.

Families strolling along the promenade, school children posing for the cameramen, crowds pouring off the paddle steamers, disasters, notable events: all recorded by local photographers whose photographic evidence has been invaluable to record life at that time. Local people can look back along their family tree and see how their grandparents and great grandparents would have lived, what they would have done, or how they would have been dressed. This selection will, hopefully, enable people to look back and become more aware of their family's history.

There is a growing fascination with the past and the enthusiastic work of the Harwich Society has contributed enormously to this interest, raising local awareness about the heritage and history of the area.

I trust readers will enjoy this second selection and I will be pleased to hear from anyone, via the publisher, with anecdotes and stories about views and events featured in this book.

P. Cowley

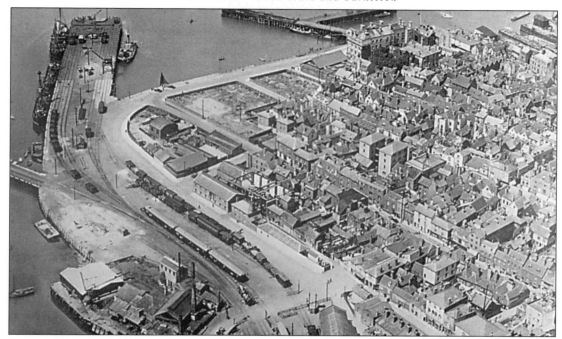

HARWICH TOWN AND PIERS FROM THE AIR

Harwich in the late 1920s and a significant feature must be the density of the housing. The Treadwheel Crane is still on the Naval Yard and a vessel is on the slipway although the yard was on its last legs and soon to be dismantled. The charred remains of the part of the Halfpenny Pier, destroyed by fire in 1927, can be seen. Railway lines run straight on to the rebuilt Continental Pier where wagons were stored prior to shipment on the train ferries. In the foreground, the buildings belonged to the Harwich Gas and Coke Company. The derelict land on the Quay front was used for many years as a site for a travelling fair.

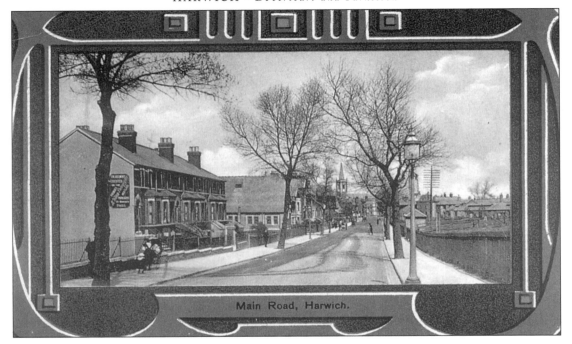

Main Road, Harwich.

MAIN ROAD, HARWICH

This view of the road into Harwich shows the Masonic Hall (just beyond the terraced houses). Initially, it was the Public Hall, a red brick building erected in 1886 and costing £1650. At the second AGM, an income of £205 and expenses of £138, left £67 available for distribution to shareholders. Eventually, a 5% dividend was declared and £33 was kept in the Reserve Fund. The auditorium could hold 500 people, had a large stage and 5 dressing rooms. The use of the hall varied from pantomimes and amateur dramatic performances in aid of the Harwich Soup Kitchen to concerts and public meetings. It was converted into the Masonic Hall in 1907.

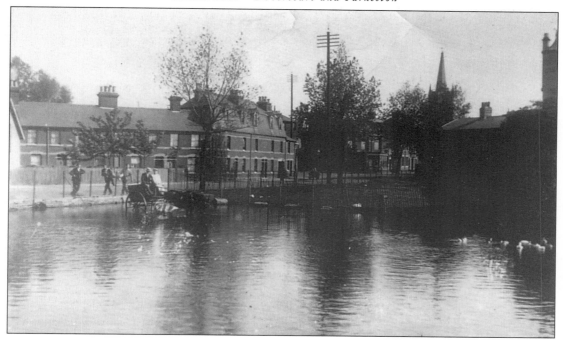

COX'S POND, HARWICH

An early view of Cox's Pond at the turn of the century. The little wooden 'house' for the ducks had yet to be added - in fact it was just a pond at this time. It was also, as can be seen here, a watering place for horses, the horse and carriage being the main method of transport for many people. The view across the road has remained largely unchanged and the two landmarks - the Church and the High Lighthouse - seem to predominate wherever the photographer happened to be.

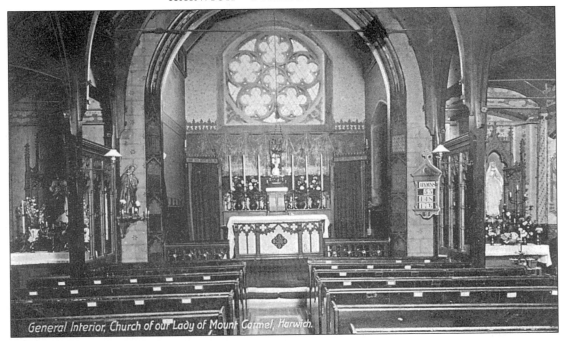

General Interior, Church of our Lady of Mount Carmel, Harwich.

GENERAL INTERIOR-CHURCH OF OUR LADY OF MOUNT CARMEL

Countess Tasker of Brentwood visited Harwich in 1863 and was astounded to find that there was no Catholic Church "in a seaport the size of Harwich". The explanation from Archbishop Manning was financial, so she pledged £500 towards building a Catholic Church. Mass was initially celebrated at 10 Kings Quay Street as it proved more difficult than expected to find a site, due to much opposition to the Catholic religion. A piece of land was eventually purchased for £445 and a Church finally built and opened on 3 November 1869 by Archbishop Manning, the Roman Catholic Archbishop of Westminster.

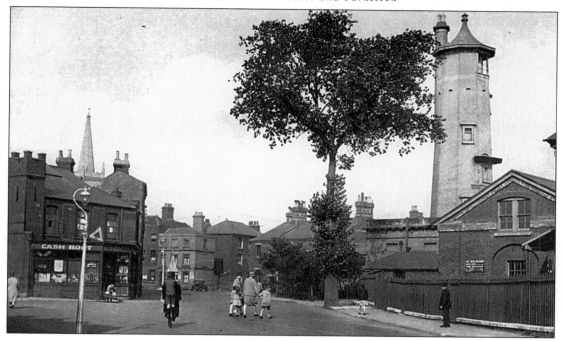

DOVERCOURT ROAD, HARWICH

What would be made today of the boy standing on the back of a bicycle? A car negotiates the fountain, which can be seen above the boy's head, as it turns into Wellington Road. On the left is the Salvation Army Citadel and Mr Lovett's "Cash Boot" where local people could take their boots and shoes for repair: his slogan was "For efficient repairs go to the corner shop with the square reputation". On the right are the Army Ordnance Buildings, destroyed during World War Two by a German land mine.

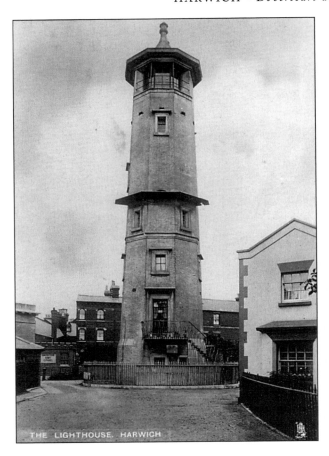

THE LIGHTHOUSE. HARWICH

THE LIGHTHOUSE, HARWICH

The High Lighthouse, with its partner the Low Lighthouse, guided mariners through the sandbanks and shoals. However, shifting sands made them unreliable and they were replaced by the lighthouses at Dovercourt in 1863. This view is looking towards West Street and shows the Salvation Army Citadel across the road. The lighthouse was, at this time, being used as a private residence. Work began on the two lighthouses in 1817 with the High Light having nine oil burners and reflectors and the Low Light three. Once an extra oil burner was added, it was claimed that the lights could be seen for up to 13 miles out to sea.

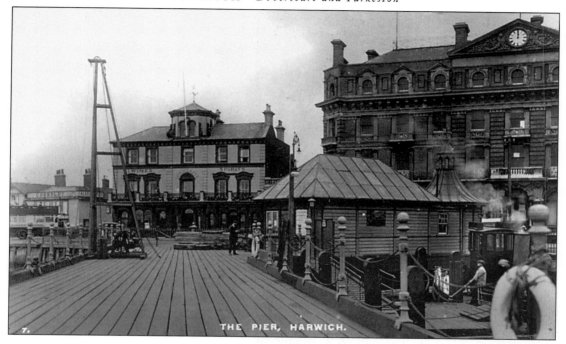

THE PIER, HARWICH.

THE PIER, HARWICH

Looking from the Halfpenny Pier towards the Great Eastern and Pier Hotels in all their glory. A double-decker Silver Queen bus can be seen outside the Angel. With three licensed premises in a row, the locals were well catered for. The Harwich Licensing Sessions of 1897 noted that there were 32 fully licensed houses in the town, 9 "on beer" houses and 4 wine cellars. Harwich had a population of 5089 at this time and with 45 outlets for beer and wine, there was one for every 150 inhabitants. Dovercourt had 9 licensed premises for 2710 people at this time.

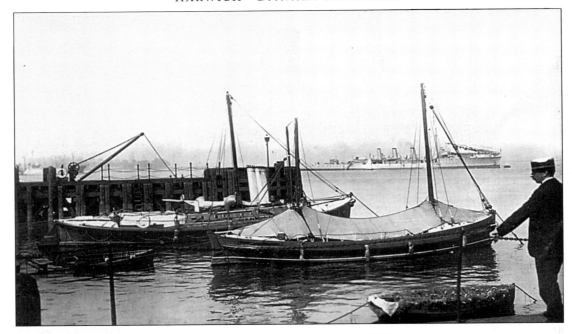

HARWICH PIER AND HARBOUR

The steam powered *City of Glasgow* and the sailing lifeboat *Ann Fawcett* can be seen in the pound. The sailing lifeboats had to be towed to the scene by the local tugs *Merrimac* or *Spray*. Distress calls were regular; many were false alarms, but one cannot but admire the courage of the crew. *The Duke of Northumberland* was 50 feet long with a 12 feet beam. The 2 engineers and 2 firemen were battened down below, which required a great deal of courage. If anything went wrong, they had little chance. The lifeboat had two water-filled tanks equal to the weight of a shipwrecked crew whilst steaming out to a wreck, then pumped out when the crew were saved and brought ashore.

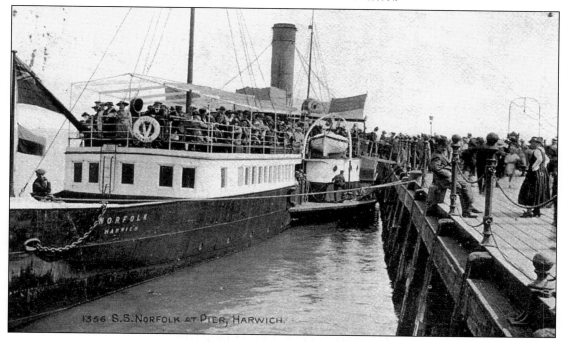

1356 S.S. NORFOLK AT PIER, HARWICH.

S S *NORFOLK* AT HARWICH PIER

The Great Eastern Railway, in addition to their sea-going fleet, had paddle steamers for the ever popular local excursions. The *Norfolk* came into service in 1900, mainly for Ipswich to Harwich excursions. The arrival of a steamer always drew a large crowd on to the pier, but this was usually exceeded by the numbers leaving and boarding. First class passengers had 2 saloons fitted with polished hardwood, settees upholstered with olive green velvet backs and cushions, and a special cabin with lavatory accommodation for ladies. The second class passengers had white wood panelling with sparred wooden seats along the sides and the end. On the main deck were the lavatories for men. The paddlers had electric lighting and could achieve a speed of 12-14 knots.

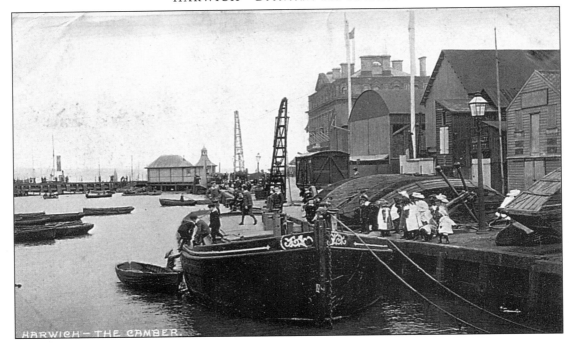

HARWICH - THE CAMBER.

THE CAMBER, HARWICH

At the turn of the century, children found much to entertain them on the Quay Front from watching the comings and goings of the fishing vessels (fishing at this time was thriving) to the excitement provided by this barge moored alongside the Quay, jumping from one to the other. The warehouses behind the children were built by the Great Eastern Railway for storage and the presence of the rail wagons on the Quay show the importance of that rail link in earlier days. Notice the crane behind the barge. Fish was stored in large cod chests before being transported on to Billingsgate fish market in London.

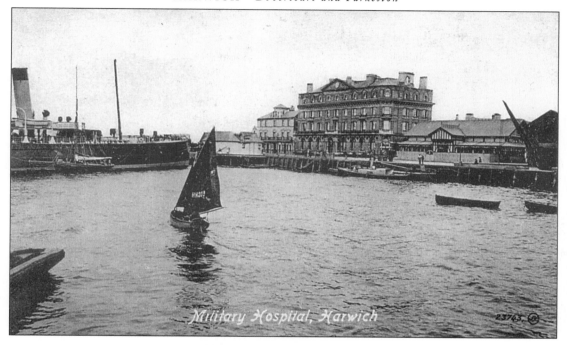

Military Hospital, Harwich

MILITARY HOSPITAL, HARWICH

During the Great War, the Great Eastern Hotel was used as a military hospital. The hotel itself was built to accommodate passengers who were waiting to board the continental steamers, which were often delayed. On the *Suffolk's* inaugural voyage, local dignitaries were taken on a trip to the Cork Lightship and were then given luncheon by the GER in their new "hotel pavilion", built in "Swiss chalet style". It was probably constructed to redirect the many excursionists from the main hotel where it could get decidedly crowded. In later years the pavilion became the HQ for the Harwich Naval Sea Cadets and after World War Two was more commonly known as the Quay Pavilion.

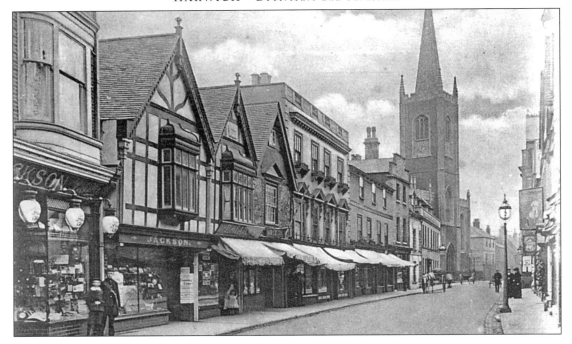

CHURCH STREET, HARWICH

This early view of Church Street, unusually quiet, shows Jacksons, the first shop seen on the left hand side. Next door is the shop of R Meadows and then the striped barber's pole of Mrs Blosse, whose hairdressing business had been in existence for many years at number 57. Jackson's business was very successful and renowned as an excellent bookseller, who had the ability to locate any book not stocked. They also printed and published *The Harwich Newsman* on the premises, which accounts for small adverts for Jacksons inserted amongst the snippets of local news. The shelves were always full of stationery and local post cards.

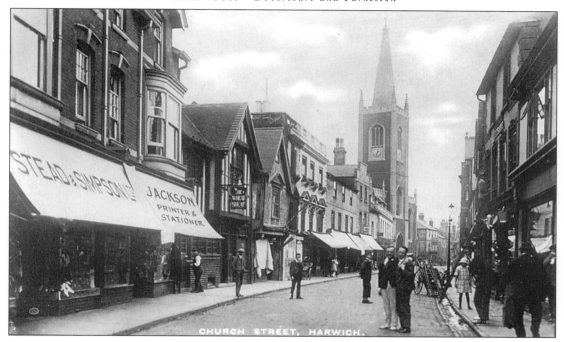

CHURCH STREET, HARWICH.

CHURCH STREET, HARWICH

This view taken in the late 1920s, but from a similar position, as page 12, starts with Stead and Simpson at number 53 and Jackson's at 54. A Leicester company, Stead and Simpson opened a branch at 53 Church Street in March 1889 . Next door to Jackson's is the only Cooperative public house in the country, The Wheatsheaf, where the customers could get their divi with their drinks. Other shops on this side of the road included Blosse (tobacconist/hairdresser), Wills (baker), Parsons (jeweller), Bevan and Stooke (chemist) and Bernards (outfitters).

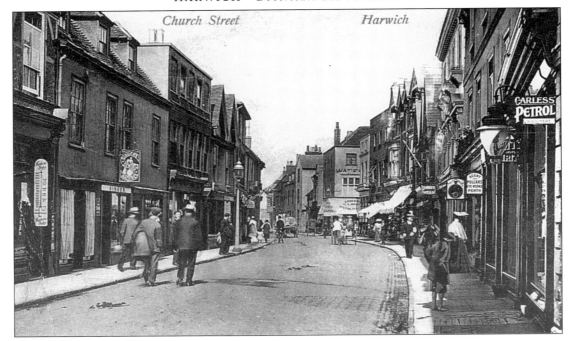

CHURCH STREET, HARWICH

Probably taken a few years earlier, c.1907, the products advertised are interesting - Carless petrol is for sale, Pullar's dyes, Jaeger wear, Stephen's inks, Singer sewing machines, to name but a few. In the distance, is the grocery store of Harry Wright, whilst immediately opposite can be seen the distinctive building of Woodwards, chemists. Mary Bullock had the tobacconist at 57 and D Wills, the baker, advertised the fact that he was a 'Gold Medallion Baker' and that his premises were always open for inspection. On the left-hand side is the Singer sewing machine shop.

PARISH CHURCH, HARWICH

c. late 30s or early 40s. On the noticeboard outside the Guildhall, a poster refers to both 'air raids precautions' and 'blackout'. The Town Council moved from the Guildhall to the Great Eastern Hotel in 1951. The Harwich name of Bevan and Stooke had been offering their services to the people of Harwich since 1828. In the 1880s, Mr Bevan was regularly recommending the use of Sarsaparilla bloodmixtures, quinine and iron tonic, balsam of horehound and amygdaline. Surprisingly, the death rate was generally falling! Next door were the premises of Bernards. Next to the Guildhall, the 'Fish and Chips' sign belongs to Parietti's shop.

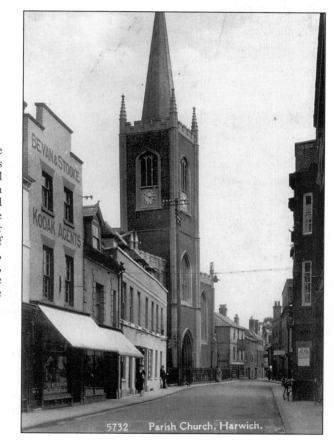

5732 Parish Church, Harwich.

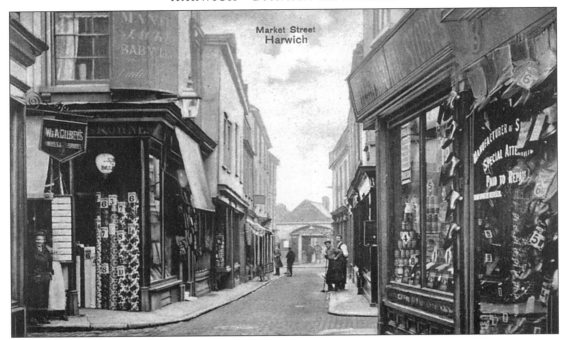

MARKET STREET, HARWICH, EARLY 1900s

Looking towards the entrance to the old Harwich market, which was paved using wooden blocks in the 1880s . The shoe shop in the bottom right is that of W Went, a family business operating through much of the nineteenth century. Hand-made water boots were a speciality and he also supplied other local retailers. Groceries could be purchased from the International Tea Store and over the road was Browne's Drapery. Market Street, along with the other streets in Harwich, would have been a hive of activity with two public houses, the Royal Oak and the King's Head, and 18 other shops of all types.

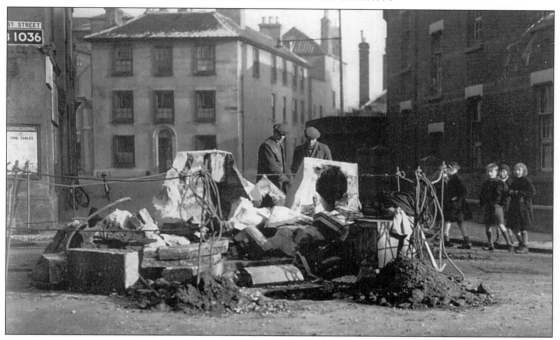

FOUNTAIN FOLLOWING EXPLOSION, WEST STREET

The fountain was erected in West Street, at the junction with Wellington Road, in 1903 thanks to the generosity of Alderman William Groom and when most transport was horse drawn. It was functional, but as piped water became the norm, the fountain became more decorative than practical and to some, an inconvenience. As motorised transport became more common, to some people the fountain seemed like a 'white elephant'. It was reduced to a heap of rubble on 21 December 1946 and it appeared that only the fountain suffered any damage. Proving the cause was more difficult - a gas build up, terrorist activity, local mischief makers? - the answer was never found, but it makes a good story.

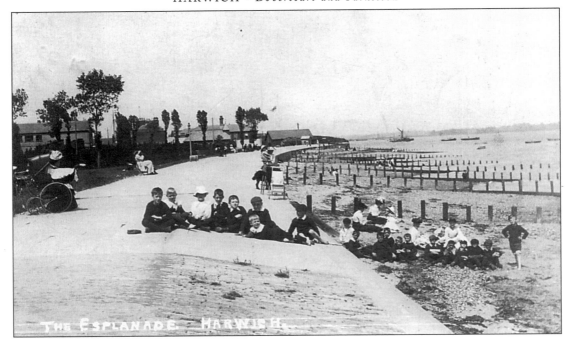

THE ESPLANADE HARWICH.

THE ESPLANADE, HARWICH

A group of 20 boys, possibly from the Esplanade School, pose for the photographer at the turn of the century. In the centre background are the Lifeboat House and the rooftops of the Angel Gate Coastguard Station, completed in 1853, "a fine range of houses, forming a quadrangle of 15 tenements, besides the house of the principal officer". The buildings in the left background were destroyed later by fire, and the land used to build the Electric Palace and the Fire Station.

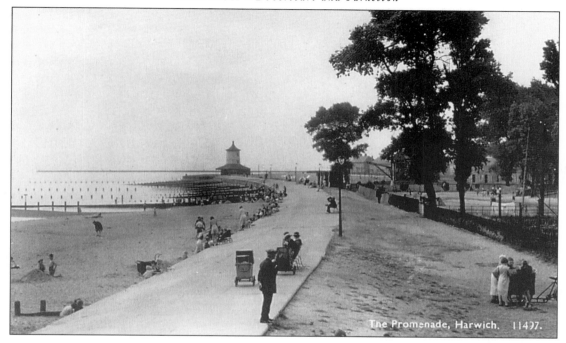

The Promenade, Harwich. 11497.

THE PROMENADE, HARWICH

A view of the Esplanade and Green, with the Low Lighthouse adding to the atmosphere. The seats are well patronised and there is plenty of sand available, although numbers seem sparse. The vendor in the foreground (possibly ice cream) is preoccupied with his customer. The trees shade the area behind, but the presence of the Treadwheel Crane dates this view around the early 1930s. The Corporation leased the Green for use as a public pleasure ground in 1912 until it purchased it outright from the War Department, along with land right through to Barrack Field. In 1923 the tennis courts, seen to the right of the Crane, were laid down.

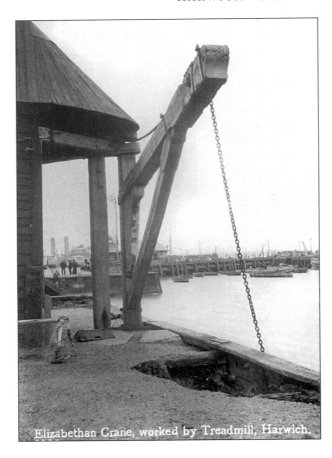

Elizabethan Crane, worked by Treadmill, Harwich.

ELIZABETHAN CRANE
OPERATED BY TREADMILL

Harwich is famous for its Treadwheel Crane removed from the Harwich Naval Yard in 1929 and re-erected on St.Helen's Green. Originally it had 2 oak treadwheels and stood in the north eastern corner of the Naval Yard (as seen above, with the train ferry and Halfpenny Pier in the background). Its importance lies in the fact that it is probably the only remaining example of its type. The treadwheels were 16 feet in diameter and 3 feet 10 inches wide. They were four feet apart and possibly operated by 2 men walking in the interior. The crane head had an 18 inch-wide horizontal beam and the whole was enclosed in an oak frame with weather-boarded sides.

THE WHITE HART HOTEL, HARWICH

Harwich was certainly not lacking in public houses, inns and hotels. Many had an historic past and the White Hart in George Street had connections with the coaching trade, was 2 storeys high and had a frontage of 55 feet. There was a bar, sitting room, commercial and coffee rooms, smoking and billiard rooms. In fact, the White Hart had everything for commercial and residential requirements. A central quadrangle with a glass roof had vines with bunches of grapes trained around it in the summer. This advertising card shows the large concert room and its electric piano.

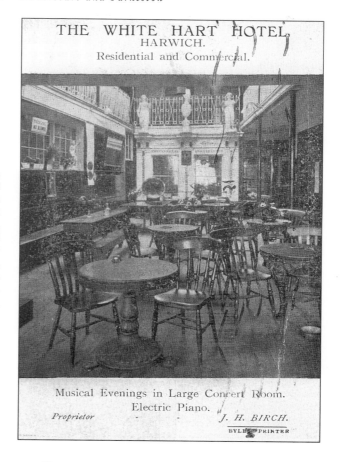

THE WHITE HART HOTEL, HARWICH.
Residential and Commercial.

Musical Evenings in Large Concert Room.
Electric Piano.

Proprietor - - - *J. H. BIRCH.*

BYLES PRINTER

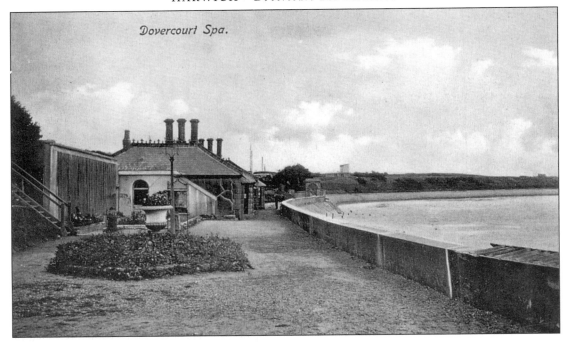

Dovercourt Spa.

DOVERCOURT SPA

Another part of Bagshaw's grandiose plans for Dovercourt New Town. The coming of the railway, the growing trends towards holidays and excursions, and water on a par with Tunbridge Wells, provided the stimulus. It was built in 1854. In the background are Beacon Hill and the arch which led around the Esplanade into Old Harwich. The 1893 season began with Henry Warren announcing that the Library and Reading Rooms were open in conjunction with Mudie's London Library and the tennis courts could be booked in advance. Warren also made a contribution to the Amusement Committee subscription with the proviso that the band played two evenings a week in the Spa Grounds.

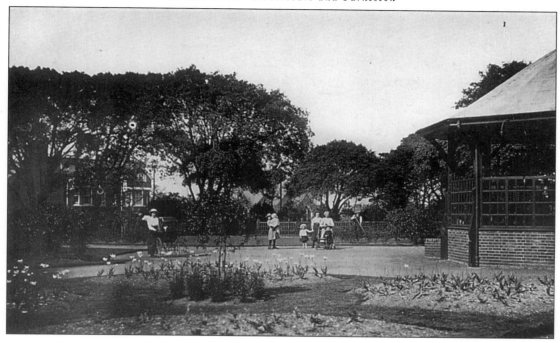

PLEASURE GARDENS AND BANDSTAND, DOVERCOURT

These were laid out in the grounds of Bagshaw's palatial residence, Cliff House. The house was later demolished and the Local Corporation bought the grounds and decided to landscape them as part of the Jubilee celebrations in 1911. They were opened by the Mayor, Alderman Groom, in June 1911.Through the trees the houses on Main Road can be seen, also the Methodist Chapel which has been demolished and replaced by apartments. Initially that area was meadowland purchased from Mr Gwynne by Thomas Moran. He offered 82 plots for sale for the erection of artisan's dwellings, shops or villa residences adding to the existing houses in Waddesdon Road and Gwynne Road.

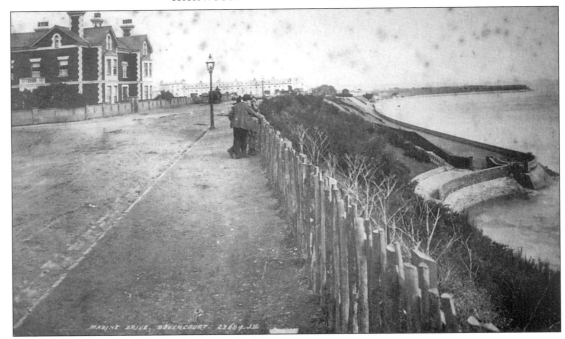

MARINE DRIVE, DOVERCOURT

MARINE DRIVE, DOVERCOURT

A view from the late 1890s looking towards Orwell Terrace before the main residential building at the park end of Marine Parade had taken place. The houses seen here are at the corner of Cliff Road. The Lower Promenade, where the bandstand had yet to be built, is empty. The wooden fencing, bushes and undergrowth bring a rustic charm to the area. In February 1897, the Corporation pointed to "the progress our seaside resort is making" and hoped that "Dovercourt will be classed as one of the most attractive and beneficial resorts for summer visitors". Work was undertaken to replace muddy gravel paths with concrete ones.

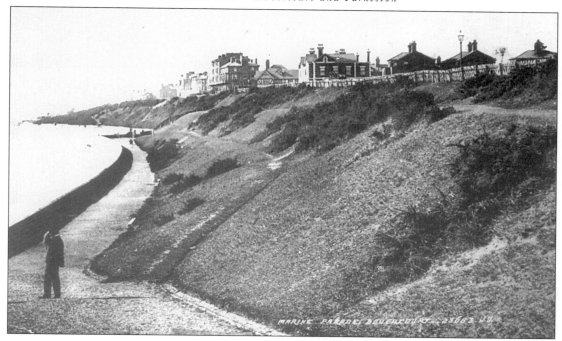

MARINE PARADE, DOVERCOURT

Looking west in the 1890s showing the houses from Cliff Road towards the "Dutch House" including the Gables and Cliff Hotel, but nothing between Orwell Terrace and Cliff Road. The shelter on the promenade was built later in 1902. The residents and holidaymakers had some excitement on a Sunday in August 1897 when fire spread rapidly along the slopes from the Cliff Hotel for about 60 yards towards the lighthouse. The dry grass and undergrowth and the strong breeze fanned the flames as bucket chains from the Marine Parade houses tried to control the fire. The local newspaper speculated that the cause was a discarded match.

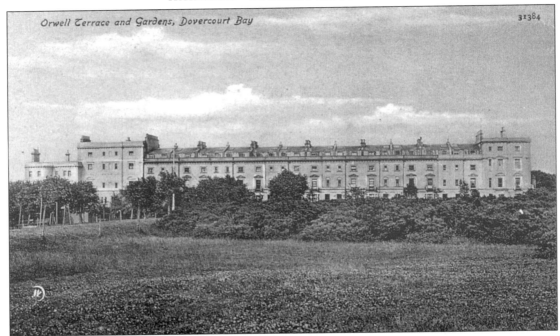

Orwell Terrace and Gardens, Dovercourt Bay

31384

ORWELL TERRACE AND GARDENS, DOVERCOURT BAY

Looking towards Orwell Terrace, across open land devoid of housing with plenty of trees and bushes. This open land was previously brickfields where the brick clay was raised to furnish the local brick and tile works which were to the east of Mill Lane. Orwell Terrace was completed in the 1850s and was a major feature of Bagshaw's plans for Dovercourt New Town. Bagshaw took up residence in the end terrace which had a marvellous view out to sea and over Cliff Park. When he became bankrupt the venture ended.

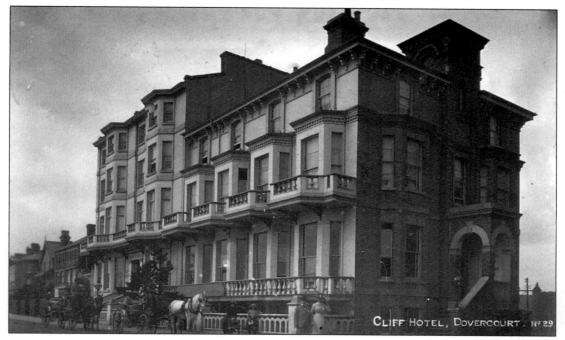

CLIFF HOTEL, DOVERCOURT. Nº 29

CLIFF HOTEL, DOVERCOURT

In the 1860s there was piecemeal development along the front at Dovercourt, but one building that has always had a commanding presence on the Marine Parade is the Cliff Hotel. Bagshaw's bankruptcy allowed Daniel & Sons (brewers of West Bergholt) to acquire the site for the Cliff Hotel and it was then purchased by the Dovercourt Cliff Hotel Company Limited in 1883. It was thoroughly refurbished and a lady manageress (ex Claridges) employed. At the end of the first year, it was announced to shareholders that "business transacted this year is far above the most sanguine expectations".

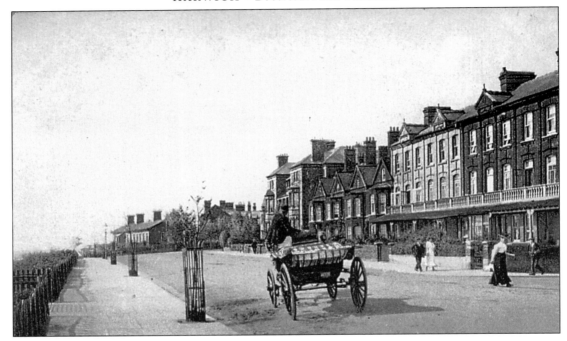

UPPER PROMENADE, DOVERCOURT

Marine Parade looking towards the Dutch Houses, long since demolished, but coming to prominence with the Queen Mother's 100th birthday, as she visited her sister who was living in the house in 1917. Few people can visualise the Marine Parade without the Minesweepers' Memorial. The houses have hardly changed apart from some structural changes, e.g. the Hotel Continental and there is a distinct lack of transport, unlike today. Trees have recently been planted and protected, and the rough wooden fencing running along the seaward edge had been replaced in the late 1890s.

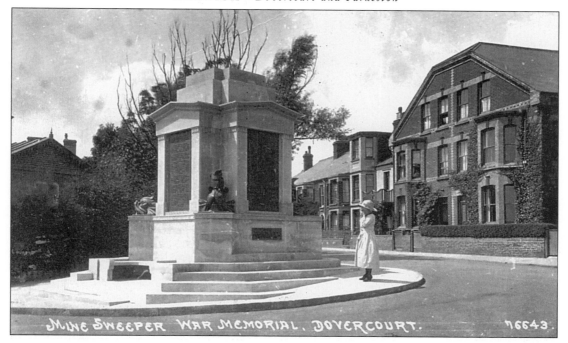

MINE SWEEPER WAR MEMORIAL. DOVERCOURT.

716643.

MINESWEEPERS' MEMORIAL, DOVERCOURT

World War One saw considerable naval activity in and out of the harbour, which served as a minesweeper base to keep the channels clear of mines and safe for merchant and naval vessels. The light cruiser *Amphion* was one of the earliest casualties off the coast to a German mine. The Harwich Auxiliary Patrol and Minesweeping Force carried out valuable and extremely dangerous work in the North Sea manned by the R N Trawler Reserve. 750 vessels and 38,000 men swept over 10,000 mines. The portland stone monument was unveiled on 16 December, 1919.

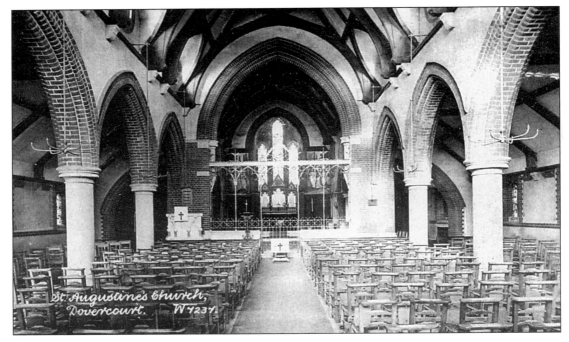

ST AUGUSTINE'S CHURCH

With the growing population in the 1870s, a new church was needed in Dovercourt. Mr Gwynne, a major landowner, offered the site at the top of Hill Road on the Cliff Estate and the foundation stone was laid on 19 July 1883. The plan was to accommodate 500 people at a cost of £4000. Initially, a 200-seater section of the church was built at a cost of £1596 and the consecration service took place in March 1884. The Church received altar furniture from Mr A J Ward and a font courtesy of Mr J Gwynne. Additional accommodation followed the extension in 1888 and the individual seats, seen here, were replaced by pews.

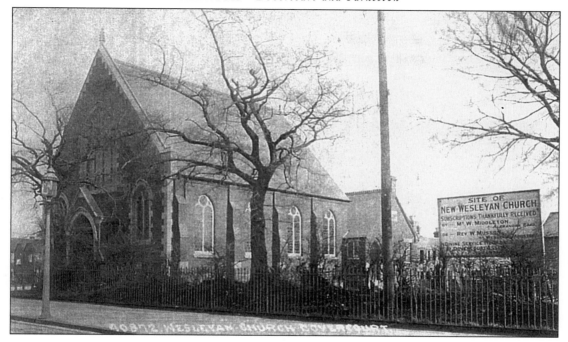

NEW WESLEYAN CHURCH, DOVERCOURT

Methodism appeared to be going from strength to strength judging by the number of chapels. The Primitive Methodists were zealous in the way they spread their message, building chapels at Upper Dovercourt (1866) and opposite the Dovercourt Park (1895). The Wesleyan Methodists had long had a church in Harwich and there was much enthusiasm when a piece of land was purchased at the top of Oakland Road in 1902. The church was opened on 22 June 1905, seating 260 at a cost of £1960. The message on the board epitomises the self-help ethos at the time when it says "subscriptions thankfully received".

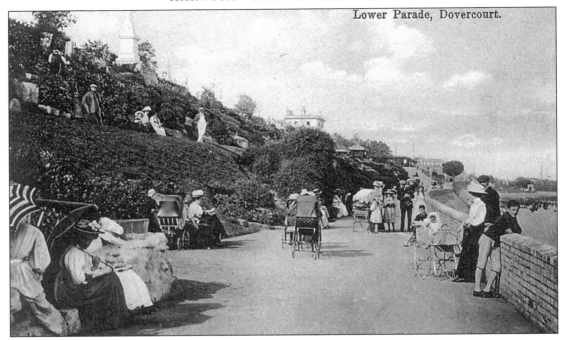

Lower Parade, Dovercourt.

LOWER PARADE, DOVERCOURT

The person visiting Dovercourt purchased this card in July 1913 although it is likely to have been photographed earlier. Queen Victoria looks down over Kingsway and the photograph was probably taken from near the bandstand on a Sunday afternoon. It would be difficult to say that the crowd was oblivious to the photographer, as the scene looks to have been stage-managed to a certain extent. There is a glimpse of the Spa in the distance and the archway which led promenaders into Old Harwich can be seen. No sunbathing for these Edwardians, just a family stroll along the promenade thanks to the ambition and endeavour of John Bagshaw.

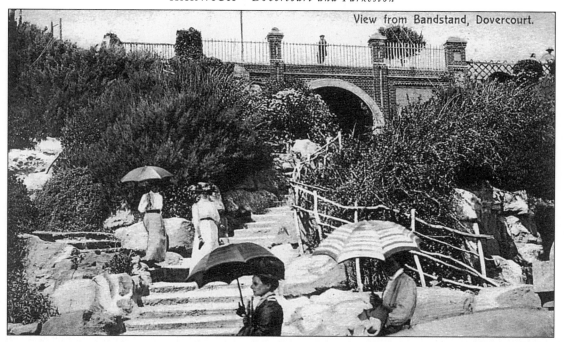

View from Bandstand, Dovercourt.

VIEW FROM THE BANDSTAND, DOVERCOURT

An interesting view of another part of Bagshaw's grandiose plans. The promenade or undercliff walk was well set out and the scheme, although visionary, proved too extravagant and forced Bagshaw into bankruptcy. Before his death, Orwell Terrace had been built along with Victoria Street and parts of Cliff Road. The Cliff Hotel had long been dominating the Marine Parade and the Spa had been built and was well patronised. This view, probably taken from the bandstand, shows the steps, rustic wooden fences and arch through to Mill Lane. The ladies, in their formal wear with their parasols, seem to have been strategically placed by the photographer.

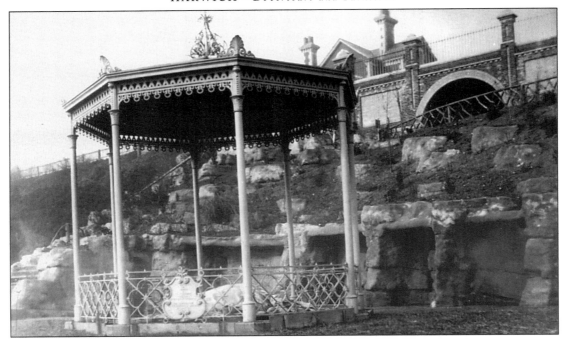

THE BANDSTAND

This unusual close up view of the bandstand shows what a marvellous addition it was to the Dovercourt seafront. Its design had not taken into consideration the problems of exposure to the elements - to the inconvenience of the performers and the public. The plaque on the front reads "Presented by the Harwich and Dovercourt Industrial Cooperative Society to the Corporation of the Borough of Harwich, October 1901." Responsibility for entertainment throughout the Borough rested with the Amusement Committee which often had to raise money through public subscription.

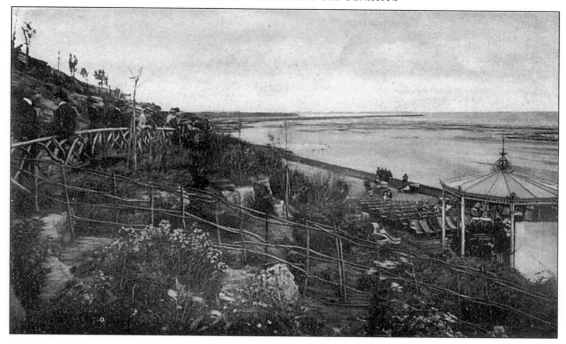

BANDSTAND AND GARDENS, DOVERCOURT

In 1904, the council purchased 200 deckchairs which were made available for the audiences. The canvas sheets, although reducing the view of the performers by the audience, at least gave them protection from the unpredictable summer weather and the cool breezes off the North Sea. It was also traditional for audiences to show their appreciation through a collection towards the end of the performance. When the canvas proved less than effective, glass partitions were added, which gave more solid protection against the elements.

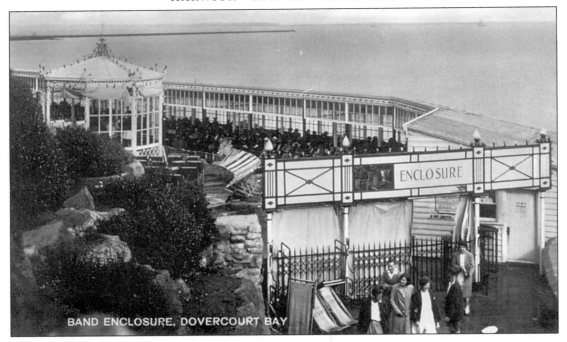

BAND ENCLOSURE, DOVERCOURT BAY

BAND ENCLOSURE, DOVERCOURT BAY

The protection offered to performers had been put in place, but the question of protection for the audiences, who were still in the open, had been discussed in Council on several occasions. It was not until April 1929 that the Town Council decided to improve the sea wall beyond the bandstand and to build an enclosure on the seaward side of the bandstand for up to 300 people. The estimated cost was £1500. It was completed and opened on 14 July 1929 by Mr Abdy, the High Steward, after which Eugene Bowen's orchestra performed "Orpheus in the Underworld", with a supporting programme, which included local soloists.

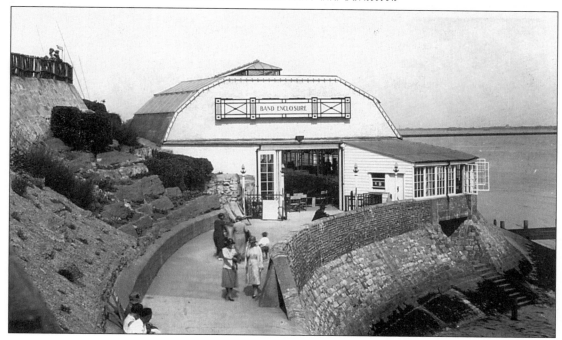

BAND PAVILION

The Dovercourt Band Pavilion, "laid out on the lines of a Central European Casino Winter Gardens", was the subject of much debate before it was constructed. Excitement was mounting as the grand opening approached in June 1932. The complaints about the cost and appearance soon disappeared as it was "generally agreed that the pavilion was wonderful value for money". To complement the new attraction for the 1933 season, the Corporation agreed to spend £400 floodlighting the beach from the pavilion to the wooden jetty with coloured lights set up along Marine Parade and down the slopes to the promenade.

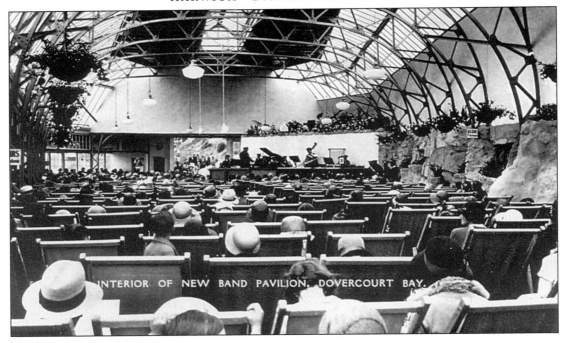

INTERIOR OF NEW BAND PAVILION. DOVERCOURT BAY.

INTERIOR OF THE BAND PAVILION, DOVERCOURT BAY

Performances within the Band Pavilion were many and varied. 300 people could be accommodated with the audiences seated in different types of deck chair. Traditional dances were regularly held, well known bands and orchestras were brought to Dovercourt as one-offs or for the season. Local talent contests were held, along with children's entertainers and competitions for children. Even indoor bowls was introduced in 1938. Perhaps the highlight was the broadcast by Wilfred Pickles and Mabel from the Pavilion in 1957. Many people were sad to see such a local landmark disappear with nothing tangible to replace it.

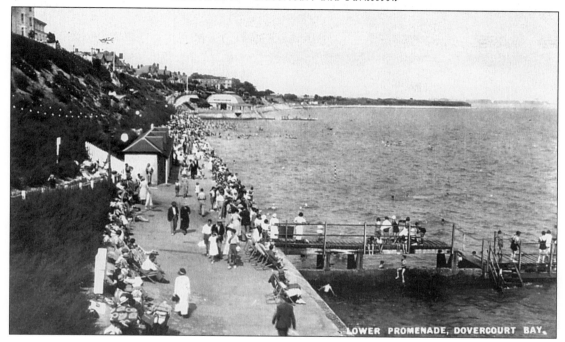

LOWER PROMENADE, DOVERCOURT BAY.

LOWER PROMENADE, DOVERCOURT BAY

A busy scene on Dovercourt sea front. The jetty in the foreground was built in the early 1900s (probably 1908) and demolished in the 1940s, probably for strategic reasons. Almost opposite the jetty many will remember the shelter with the restaurant above it. The jetty was used for strolling, crabbing, diving, and kept many children amused for days on end. The beach huts built on the promenade could be seen as an inconvenience as people squeezed between them and the people sitting in deckchairs on the edge of the promenade. The Corporation's plans for lighting the promenade can be seen with the string of coloured light bulbs.

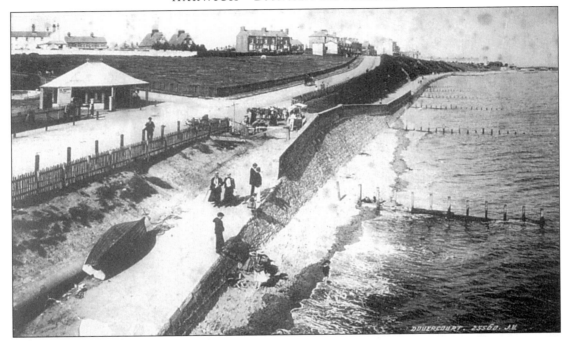

DOVERCOURT

An early view, probably taken from the lighthouse, looking towards Dovercourt. The refreshment kiosk at the bottom of Beach Road adds a touch of reality to an otherwise rather barren and unappealing scene. The donkeys look almost redundant and the ice cream vendor has very little trade. The adjoining notice advertises "The Retreat". Plenty of building land is available between the Dutch House and the bottom of Beach Road, although Fronks Road development has already taken place with Trinity Terrace and the Trinity cottages visible.

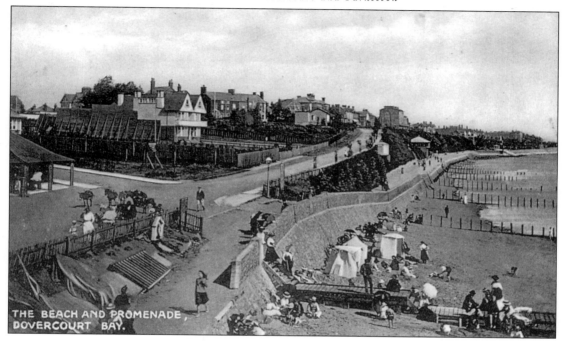

THE BEACH AND PROMENADE, DOVERCOURT BAY.

THE BEACH AND PROMENADE, DOVERCOURT BAY

A later view taken from a similar position. There seems to have been considerable development, but the sender of the card writes "Weather very wet and cold. Not many here. Very pleased with rooms but don't think much of the place." The small jetty and steps down to the beach have been built and the camera obscura and shelter/café have been built. There has been some building along Marine Parade and into Beach Road, although there are still vacant plots. The trees planted along the Marine Parade add to the general ambience and there is now a gas light.

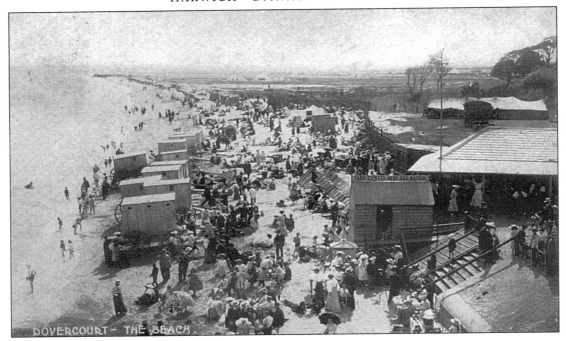

DOVERCOURT - THE BEACH.

DOVERCOURT SANDS

The Bathing machines seen here gradually became the butt of seaside jokes and eventually disappeared to be replaced by more permanent beach huts, which can be seen in the next photograph. The beach is crowded and the bathing machines could be hired to lower swimmers into the sea for a dip and then haul them back out to maintain their modesty. Indeed, at one time mixed bathing was frowned upon and strict rules were enforced for beach and swimwear. The bathing machines were the property of the Phoenix Hotel whose brewers (Daniel & Sons) had bought the sole rights to erect bathing machines for 300 yards from the south end portion of the Cliff Estate.

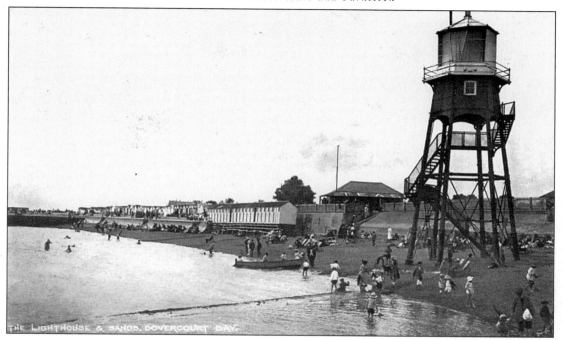

THE LIGHTHOUSE & SANDS, DOVERCOURT BAY.

LIGHTHOUSE AND SANDS, DOVERCOURT BAY

The bathing machines have disappeared to be replaced by more permanent beach huts on the edge of the promenade and also in a jagged pattern on land beyond the new promenade. More interestingly, this type of lighthouse was pioneered on the Maplin Sands. Opened in 1863, the long metal legs were pile driven into the sea bed and then secured. Iron rods were then put across and the lighthouse built on top. Wave and wind resistant, the iron rods are still standing after 137 years. The Two Lights were joined by a concrete causeway, which gave access at most times other than high tide. They were made redundant in 1917 when buoys were laid in the entrance to the harbour.

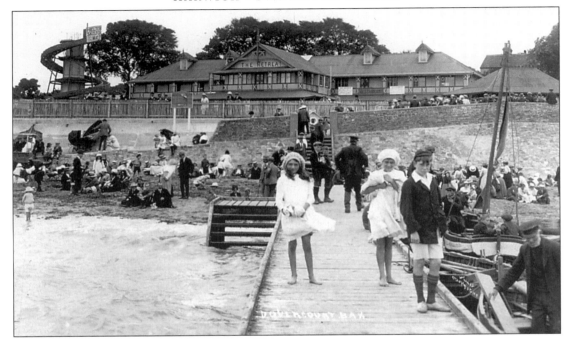

THE RETREAT FROM JETTY, DOVERCOURT

Photographed from the wooden jetty looking towards the Retreat. The small boats moored alongside offered trips around the bay for locals and holidaymakers. Riggs's Retreat is first mentioned in Kelly's Directory in 1890 and stood next to the Phoenix Hotel at the bottom of Beach Road. There were swings for the children and "Helter Skelter on the Mat 1d". It was a large wooden building with a corrugated iron roof which was sold to a Mr Gray in 1893. It catered for local parties as well as excursion parties to the town and built up a reputation for excellent refreshments.

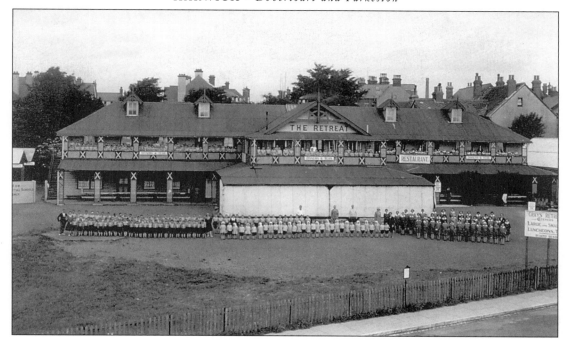

THE RETREAT

The Retreat could cater for 2000 customers. Many companies chose to have their annual outing to Harwich where they would use the Retreat because of its position facing the lighthouse and beach and its first class catering service. In 1897 the employees of Warne and Co (London) came on two special trains and "partook of tea at the Retreat and the Tottenham Town Band performed on the beach." This picture shows the groups of schoolchildren who spent time here. The card reads "We are now ready for the return march" to Dovercourt Station. Over 200 children could be accommodated in large dormitories. It was taken over by the Army during World War Two, but after the war it never regained its popularity.

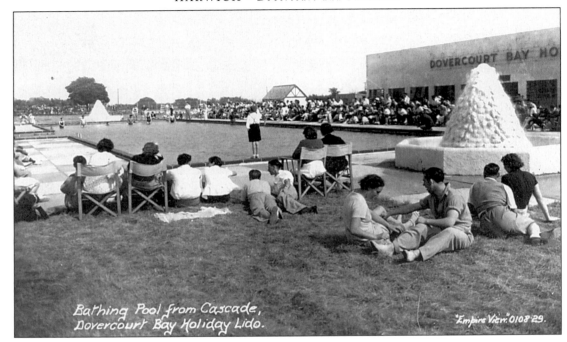

Bathing Pool from Cascade,
Dovercourt Bay Holiday Lido.

"Empire View" 0108 29.

BATHING POOL FROM CASCADE, DOVERCOURT BAY HOLIDAY LIDO

The Dovercourt Bay Holiday Lido (famous as the location for Hi-Di-Hi) was built in 1937 in a joint venture between Captain Warner and Billy Butlin. It was soon requisitioned during World War Two and became a Forces Camp used for bomber gun turret training, as well as a centre for refugees, prisoners of war and the Armed Forces. After the war, it reverted to a holiday camp and the first Entertainments Officer was Bill Owen of "Last of the Summer Wine" fame. It has now been demolished and a housing estate built on the site.

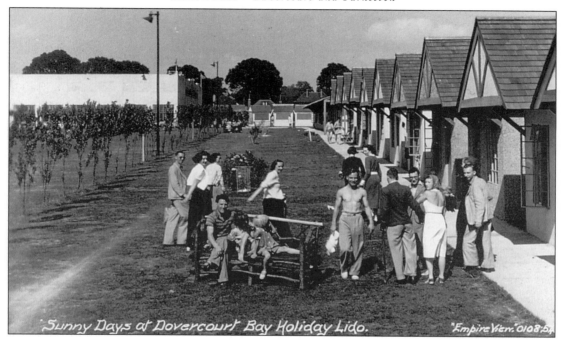

"Sunny Days at Dovercourt Bay Holiday Lido." "Empire View." O108:54

SUNNY DAYS AT DOVERCOURT BAY HOLIDAY LIDO

The post-war tariff for Dovercourt was "from 55/- per week". The new concept had everything for those wanting a week away from the normal dull routine. A bathing pool and boating lake, golf, badminton and tennis, darts and dances - what more could be wanted for the perfect week? Row after row of brick built chalets, all with running water, lino and rugs. All mattresses were interior sprung and wool blankets came as standard - in the middle of summer! Campers were entitled to 4 meals daily. One drawback was that you had to share the baths with other holidaymakers.

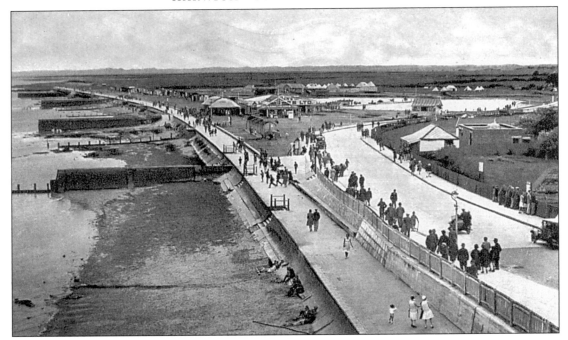

PLEASURE GROUNDS AND BOATING LAKE, DOVERCOURT

High unemployment during the post-war Depression necessitated public works programmes initiated by local and central Government. The local council took advantage of Government funding to carry out some necessary work to Dovercourt seafront. The concrete promenade beyond the lighthouse to the West End area was built - about a mile in length. There was a sandy area and then a zig-zag row of beach huts. A boating lake, children's paddling pool, swimming pool, model yacht pond and tennis courts all enhanced the appeal of Dovercourt to holidaymakers and excursionists. Butlins also set up a small amusement area behind the beach huts, in front of the yacht pond, with entertainment for children of all ages.

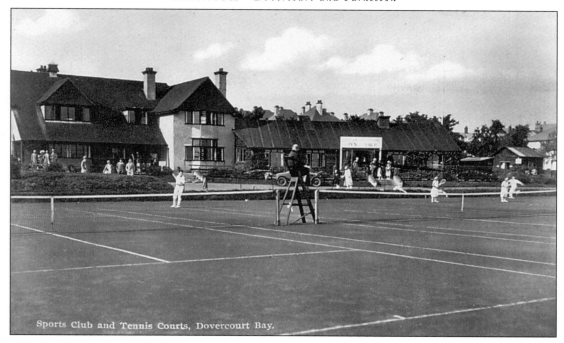

Sports Club and Tennis Courts, Dovercourt Bay.

SPORTS CLUB AND TENNIS COURTS, DOVERCOURT BAY

Tennis always seemed to be a popular sport locally and the players were well catered for. There were the Hillcrest Courts in Brooklyn Road, those attached to the Alexandra Hotel, and Parkeston players had courts in Hamilton Park. The Dovercourt Sports Club, established by 1912, had 7 courts and May 1913 saw the 2nd open tennis championships with the press commenting that "the 7 courts have been practically relaid since last year". The courts were deemed to be "in beautiful condition for hard and fast play". In 1923 the Council contracted En Tout Cas to lay three hard courts on Harwich Green and 3 hard courts in Dovercourt almost opposite the model yacht pond.

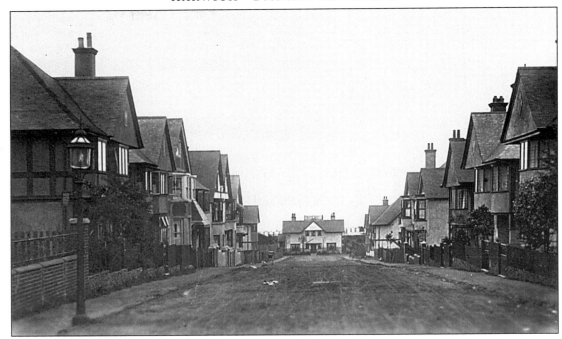

ST MICHAEL'S ROAD, DOVERCOURT

St Michael's Road was part of the accelerated programme of house building in the Fronks Road area after 1906. By 1906, at least 18 houses had been built along Fronks Road, and Lee Road and the Avenues had already been built. St Michael's was to be the central avenue of a new estate where substantial plots were being freed with 30-40 feet frontages and 140-170 feet depth, including opportunities for bungalows. Some of the houses were residences for naval and military personnel as well as local businessmen. By 1913 there had been development in Seafield Road and St George's Avenue.

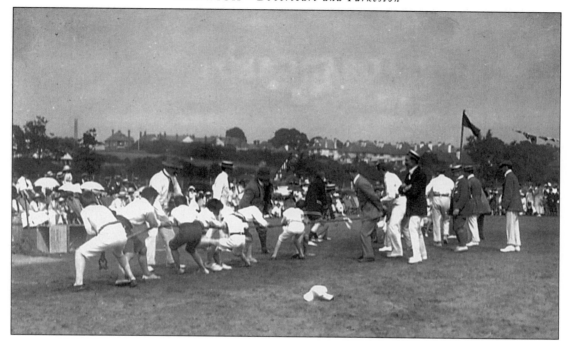

TUG OF WAR ON THE SANDS AT DOVERCOURT

With no television and few distractions, sports days, water sports, swimming galas, and regattas were always popular. This view on Dovercourt sands shows the increasingly popular tug-of-war, which sometimes got out of hand as other men and boys joined in. The presence of troops, volunteers on annual camps and naval personnel all contributed to the fun and they often held their own events. The YMCA held annual sports days on the Royal Oak Meadow and regattas were held on Harwich Esplanade. Sports galas on the Phoenix ground, Harwich Volunteers sports on the Barrack Field - the venues were many and varied and thoroughly enjoyed by the locals with big crowds watching.

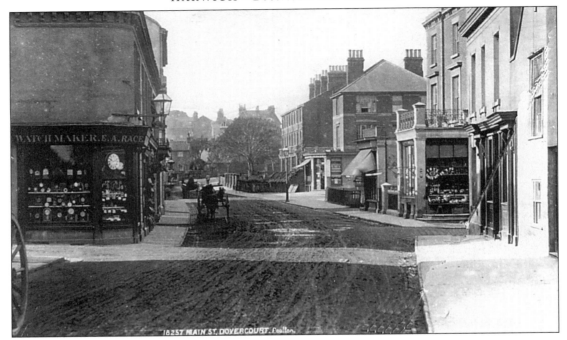

18257 MAIN ST. DOVERCOURT. *Poulton.*

MAIN STREET, DOVERCOURT

Dovercourt developed steadily from Orwell Terrace in the late 1800s. Looking up Main Road, the shop at the bottom of Orwell Terrace belonged to watchmaker E A Race. Ambrose Race died aged 42 in 1898 of heart failure and later photographs show the same shop owned by O T Blosse, tobacconist. The view up the street is clear and still mainly residential. The Kings Arms stands opposite, and the shop which was to become Harryott's Cycle Shop is across the road. There is another shop (Brown's greengrocery store in 1898), and beyond, Willson's Bazaar has not yet been built.

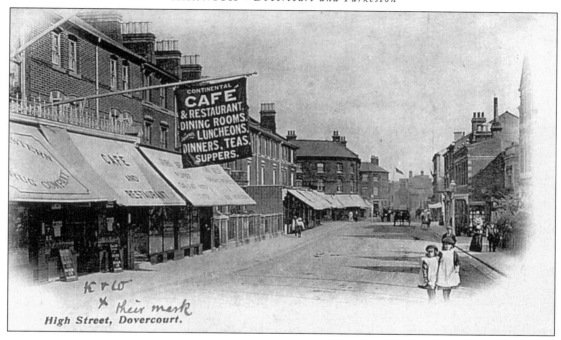

High Street, Dovercourt.

HIGH STREET, DOVERCOURT

A different view showing development around where the traffic lights are today, photographed between 1898 and 1903. The Cooperative store with restaurant and hall was built in 1902. The Eastern Drug Company occupy the first store on the left and next door is the well advertised Continental Café. This was owned by the Mastaglio Brothers offering French and Italian cuisine, breakfasts, luncheons, dinners, tea and supper. Did it ever close? Next door is John Self, ironmonger, plumber and gasfitter. There are also several buildings which were houses and apartments which, in due course, would be converted into shops before World War One.

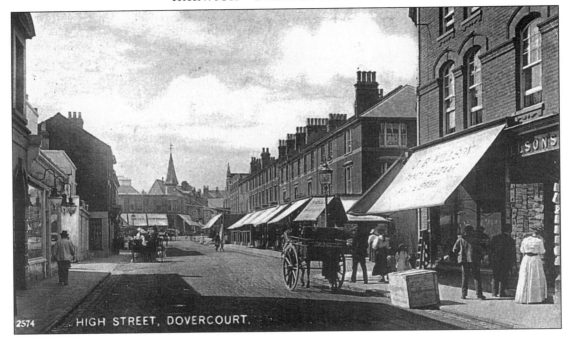

2574 HIGH STREET, DOVERCOURT.

HIGH STREET, DOVERCOURT

Photographed in 1904, with the main activity outside Willson's Bazaar with its large display of postcards, library, post office, newspapers and magazines. Over the road, next to the Queen's Hotel, is Thompson's Cash Stores with its large gas lamp. Wells' stationery shop is on the corner of Station Road and numerous other shops have been built beyond Wells including: Denney (fishmonger), Smith (grocer), Stannard (watchmaker) and JT Ward (hairdresser). The Co-op is well established and the advertising flag of the Continental Café is prominent in the right background.

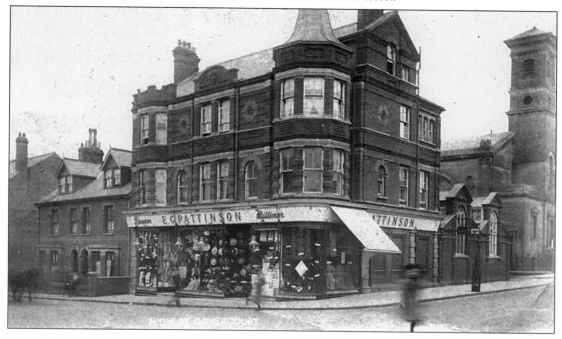

HIGH STREET, DOVERCOURT

One of the stores which started the development at the top end of High Street was Pattinsons which was built and opened in 1902. The windows were packed with goods from "a choice selection of blouses" with "noted value in gloves, hosiery, vests, etc" to "costumes and skirts". The terraced houses next door have not yet been converted into shops (Caldwell & Powell) and the Evangelical Church can be seen. Formerly the Dovercourt Mission Hall and part of Bagshaw's development, it was built in 1864 at a cost of £2500, to seat up to 700 people and to replace smaller buildings in Orwell Terrace.

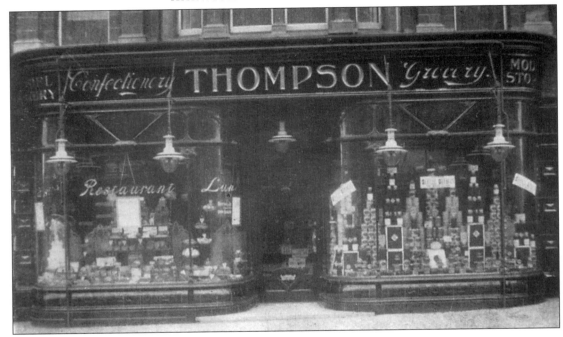

THOMPSON'S MODEL STORES

W W Thompson opened his Model Stores in High Street in 1906. He came to Dovercourt in 1884 joining ex-mayor Martin King who owned a grocery store and off-licence at the bottom of Orwell Terrace. He became a partner and eventually took over when King left the district. As a member of the Plymouth Brethren, he was a man of strong religious beliefs and conviction , holding regular services in the Assembly Hall and open air services in Orwell Terrace. The story goes that when a heckler asked him to reconcile his beliefs with his selling of "spirits which are the ruin of this country", he could not, and duly sold up and had the new store built and opened in 1906.

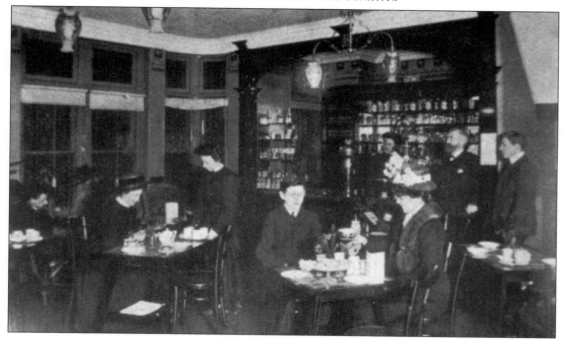

THE TEA ROOMS, THOMPSON'S MODEL STORES

The store sold groceries downstairs and had tea rooms upstairs where people were served tea and cakes or lunch. There was even a garden roof for the very brave. When the store opened people were invited to inspect the premises and were treated to tea - good public relations at that time. The shop claimed to have brought London retailing to Dovercourt and established a reputation for high class confectionery. At this time there was no pre-packaging - 28 lb bars of salt had to be cut with a copper saw into small units and sugar and tea all had to be weighed out into individual portions by the apprentices. The store closed in 1959.

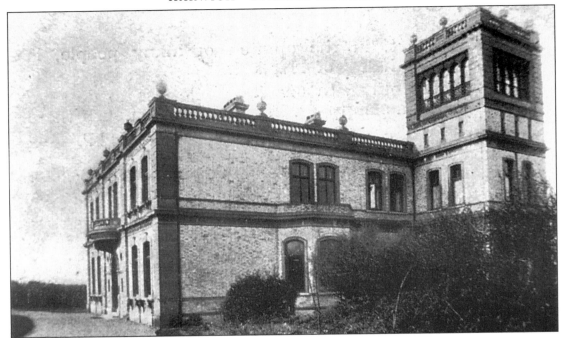

THE TOWER

Another well-known landmark is the Tower, now operating successfully as an hotel. It was built in the mid-1880s for the local cement entrepreneur J R Pattrick, who lived there until moving to the adjacent "Villa" in 1896. The building and grounds then became a school. Ernest Montague Jackson moved from Sevenoaks in 1907 and established a prep school for boys in the Tower, offering spacious and tall rooms, classically decorated and far removed from the school rooms of today. Preparing 5-17 year olds for entrance examinations, it boasted a dry playground, playing fields nearby and a gymnasium, as well as teaching all the traditional subjects.

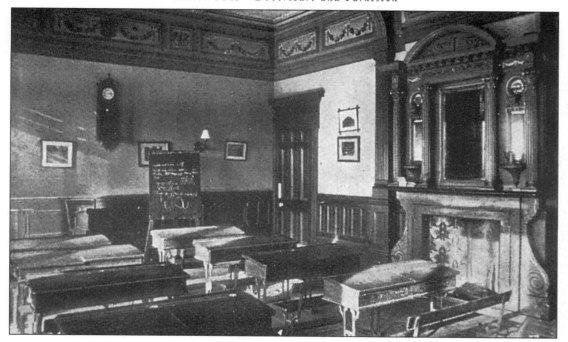

THE SCHOOL ROOM, THE TOWER

The First World War saw the requisitioning of many large buildings by the Government, and the Tower did not escape being requisitioned. Once the war ended, Essex County Council decided to purchase it as an annexe to the recently completed Harwich High School. The school room shown here was typical of the Tower which was not really built as a school. However, it served students until 1971. Many will remember the English lessons in what is now the dining room, the chemistry lessons in the bar and the interminable crocodiles of students between the Tower and the Main School, caps on heads and in twos.

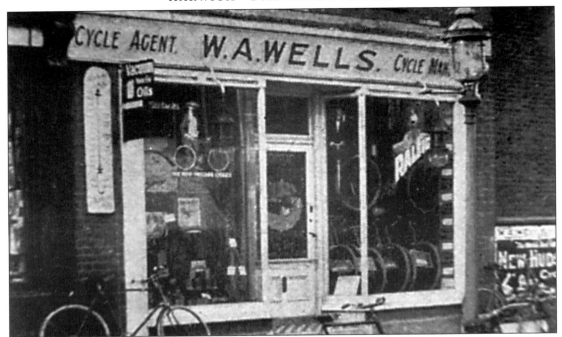

W A WELLS

This is the Station Road shop front of W A Wells, cycle and motor agent, who moved there in 1907. The trend towards using a bicycle was growing and proving popular in the early 20th century. Cycles were advertised from 5 to 17 guineas, repaired on the premises and all types of spares could be purchased. There was also a market for petrol, spark plugs and motor oils for the more adventurous. Attached to this shop was the earlier premises of W A Wells' stationery department, selling newspapers, postcards, crested china and also operating a book exchange. Wells became a household name in Dovercourt and operated from these premises for many years.

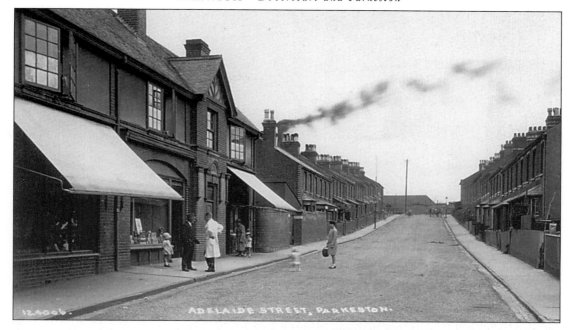

ADELAIDE STREET, PARKESTON

Adelaide Street developed in the mid-1880s on much the same lines as other Parkeston streets - rows of well-built terraced houses, where close-knit relationships developed and back doors were always open. One can imagine the communal grief which occurred when tragedy struck, such as the devastating loss of life with the sinking of the *Berlin*. The name of the street takes its name from the *Adelaide*, a paddle steamer built in 1880, the first steel-constructed vessel at Parkeston and the last paddle steamer. The shop at the bottom of the road was the Cooperative Stores. Other Parkeston streets were probably named after Lord Claud Hamilton, GER Director, Mr Garland, Lord of the Manor who sold land to the GER, and Una Wood, daughter of the Vicar of Ramsey.

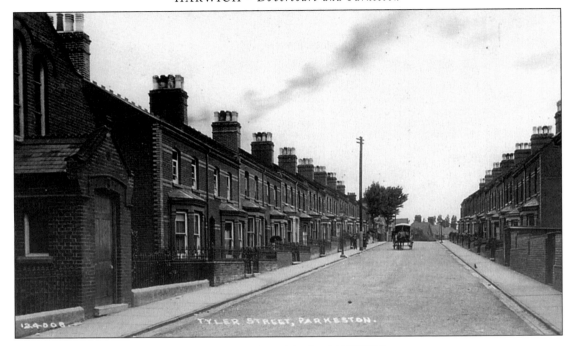

TYLER STREET, PARKESTON

The growth of Parkeston was based upon the development of Parkeston Quay when the Great Eastern Railway Company decided to move its main passenger service from Harwich to a vast expanse of land which allowed many opportunities for expansion. The venture was completed and opened on 15 February 1883 by Charles Parkes, GER Chairman. By 1901 the census showed that over 60% of the villagers were employed by the railway. Tyler Street was typical of the development, terraced houses built between 1883 and 1885. The *Lady Tyler* was a paddle steamer operating out of Parkeston Quay. The building on the left is the Wesleyan Chapel Sunday School.

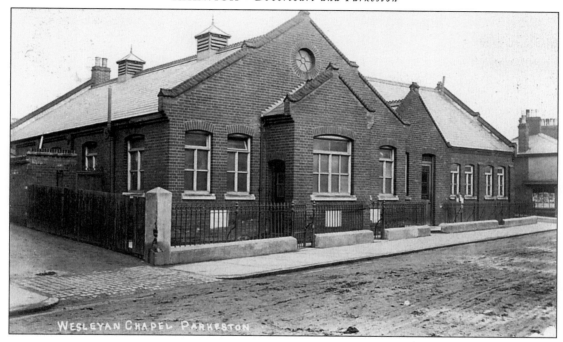

WESLEYAN CHAPEL PARKESTON

WESLEYAN CHAPEL, PARKESTON

The sender of this card to Folkestone in 1907 commented that "This is the chapel and Sunday School. The entrance is round the corner. You can see the vestry door. Hope this won't be spoilt in the post." Indeed, it wasn't. The building still stands in Garland Road with services held there regularly. Built in 1887, the church cost £900 and had a capacity of about 200. There are several foundation stones laid and some interesting bricks which have initials on them. It seems likely that, as was the trend at this time, local people were invited to make contributions to the building fund, in exchange for a brick with their initials on. The extension was built in 1896.

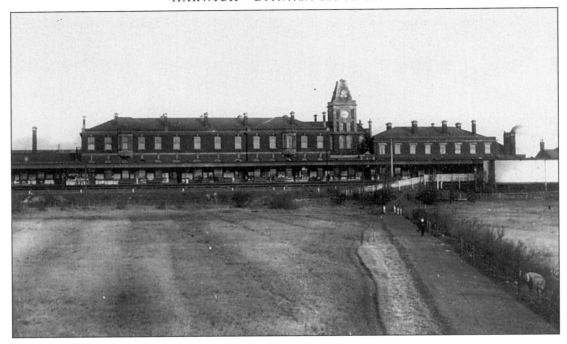

GER STATION AND HOTEL, PARKESTON QUAY

As passenger and freight traffic grew and vessels became bigger, the existing facilities at Harwich were struggling to cope. Ray Island provided the GER with the opportunity to build larger quays with room for expansion. The new 1850 feet quay was opened in February 1883. This view, across the open spaces towards the station and hotel, hides 7 berths and 2 large warehouses. The local press commented "What a contrast with the now deserted Continental Pier at Harwich. Where all was bustle and life, now nothing but quietness reigns supreme. If Harwich is to maintain her own, something must be done and now."

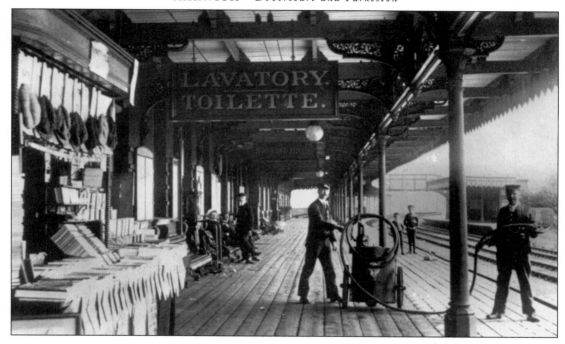

GREAT EASTERN RAILWAY STATION, PARKESTON QUAY

An early view of the wooden platformed station at Parkeston Quay which served as the arrival and departure point for passengers to and from the continent. The smaller platform on the other side was for local services. The GER passengers could disembark from their ship and, via a covered way, walk through the hotel and on to the platform. On either side of the booking hall were the waiting rooms and refreshment rooms - to the right of the Quay 2nd class, and to the left, 1st class. The 2nd class lounges had chairs and lounges covered with drab horsehair, whilst the 1st class had real Morocco leather. On the first floor the hotel facilities were described at the time as "palatial".

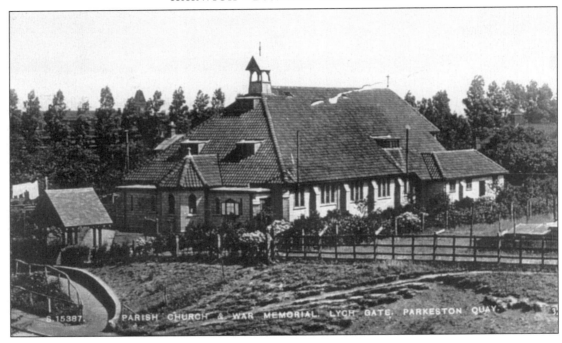

PARISH CHURCH AND WAR MEMORIAL LYCH GATE, PARKESTON

A view of Parkeston Church, probably soon after it was built, judging by the clarity of the view from the road. Initially, Parkeston was served by St.Gabriels, the so-called "Iron Church" in Hamilton Street, which was capable of seating 150. The new church, St Pauls was built by local company Fisher and Woods and could seat 350. Yellow bricks were used and the word "terracotta" has been used to describe the effect. The land was given by the Great Eastern Railway and the organ brought from the old church and dedicated to those who lost their lives in the *Berlin* catastrophe. The lych gate also has two plaques, one for each of the World Wars and the Parkeston men who lost their lives.

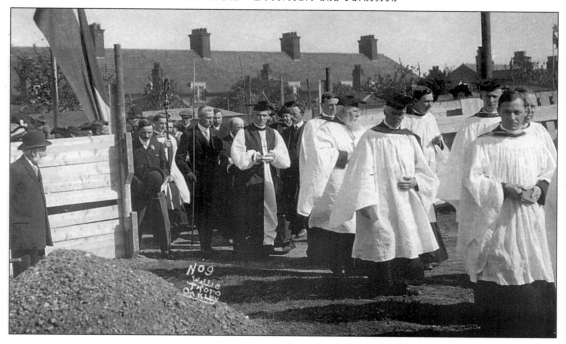

THE DEDICATION OF ST PAUL'S CHURCH, PARKESTON

Another card from the prolific cameras of the Wallis family. It shows the procession of the Bishop of Chelmsford, local clergy and surpliced choirs making their way into the church, by way of the entrance in Makins Road, for the dedication on 30 October 1914. Through the generosity of Lord Claud Hamilton, who donated £2000, only £180 was left to be funded by subscription. Inside the Church the dedication occurred at the appointed places - the lectern, the font, the pulpit, the chancel and then the holy table. Tyler Street can be seen in the background.

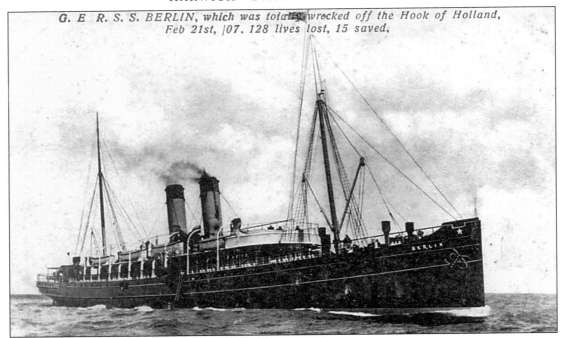

G. E. R. S. S. BERLIN, which was totally wrecked off the Hook of Holland,
Feb 21st, /07. 128 lives lost, 15 saved.

S. S. *BERLIN*

Probably the most serious accident suffered by a Parkeston Quay North Sea ferry was that involving the G.E.R's SS *Berlin*. It certainly involved the greatest loss of life. As the *Berlin* left Parkeston Quay on the evening of 20 February 1907 for the night crossing to the Hook of Holland no one could have imagined the tragedy that awaited them. The boat made the Hook on time, took on board the Dutch pilot, and then made for the New Waterway. It appears that a gigantic wave pushed the *Berlin* dangerously close to the Pier. As she was corrected, another wave pushed her on to the pier. It was several hours before she broke in two, but the state of the tide and strong winds made rescue impossible, with people visible on the ship but too far away to rescue.

CAPTAIN PRECIOUS OF THE ILL FATED SS *BERLIN*

Captain Precious was a family man with children and the senior Captain of the GER Fleet at Parkeston Quay, rising through the ranks over 25 years. At 9.30 in the morning, three hours after running on to the pier, the *Berlin* broke in two and many passengers were thrown into the raging sea with no possibility of rescue. Some survivors could be seen later on the deck and rescuers risked their lives crawling along the pier but could not reach them. Three women were actually landed on the Sunday morning at 4 am. Scarcely a street was not affected and for many days the sad little funeral processions wended their way through the town with shuttered windows and half-mast flags, and grown men weeping openly in the street.

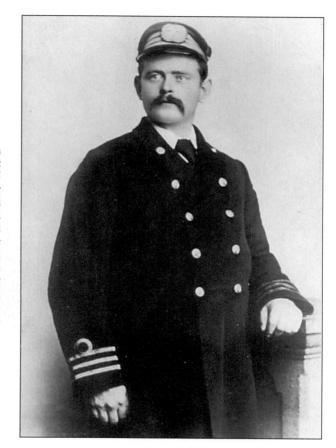

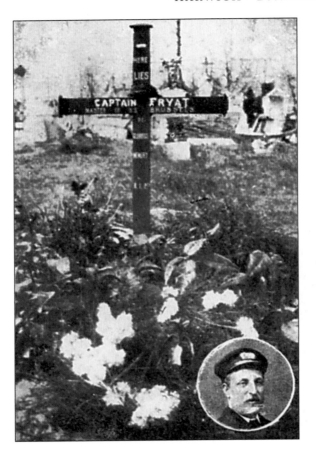

THE GRAVE OF CAPTAIN FRYATT

Many GER ships had skirmishes with German submarines during World War One, but Charles Algernon Fryatt, master of the *Brussels*, seemed to be a marked man. In 1915, as master of the *Wrexham*, he ignored instructions to stop and was presented with an inscribed watch by the GER for his courage. A few weeks later, an incident with U-33, which resulted in damage or loss, brought another watch and more publicity. A year later the Germans intercepted the *Brussels* as it steamed out of the Hook of Holland. She was boarded, the crew taken off and the ship taken to Zeebrugge. Fryatt was tried as a "franctireur" even though "he was not a member of a combatant force" on the grounds that he "made an attempt to ram the U-33 off the Maas Lightship".

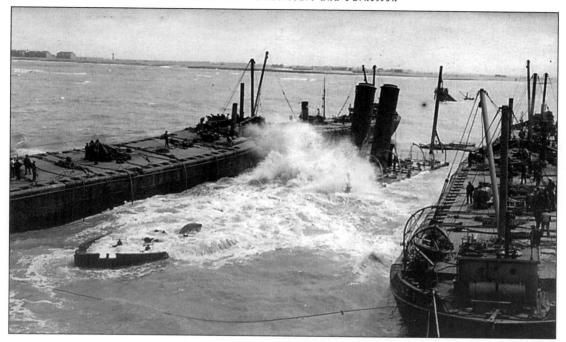

THE SALVAGING OF THE *BRUSSELS*

Fryatt was tried on 27 July 1916, found guilty and shot at 7pm. He was buried in Bruges Cemetery under a simple, inscribed black wooden cross. After the war his body was exhumed and returned to Dovercourt. Crowds lined the railway stations from Liverpool Street as his body was brought home, the front of the train having been painted white with the letter 'F' in purple and a laurel wreath. The *Brussels* was moored at Zeebrugge and then scuttled to protect the German submarine fleet. It was later raised and sold for £2100 to operate between Liverpool and Dublin. The money went towards the building of the "Fryatt Memorial Hospital".

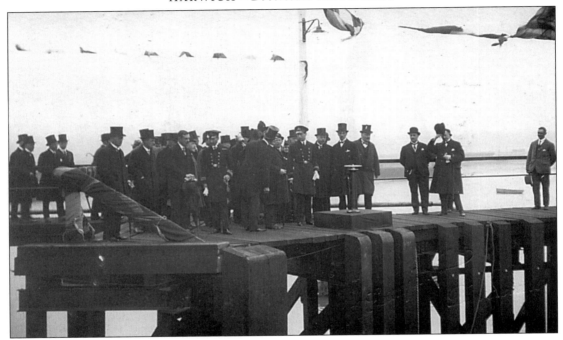

OPENING OF THE TRAIN FERRY TERMINAL

Thursday 24 April 1924 saw the opening of another chapter in the maritime history of Harwich. H R H Prince George arrived in Harwich to open the train ferry service to Zeebrugge.. This service was not the first, but because of its deep water channel and countrywide rail connections, Harwich was ideally positioned. Prince George, seen here on the quayside, was invited to set the machinery in motion and then moved on board to inspect the equipment and see the rail trucks being loaded without a hitch. Many of the guests then travelled on the *Roulers* to Zeebrugge to see Prince Leopold repeat the ceremony at the Zeebrugge terminal.

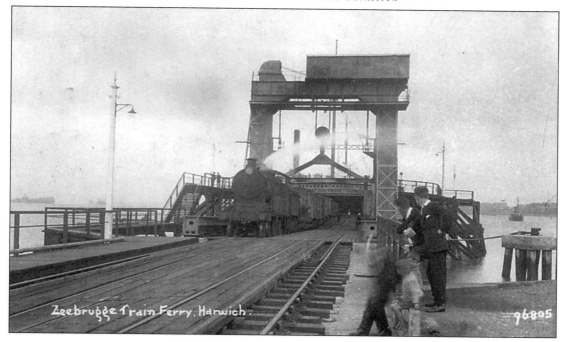

Zeebrugge Train Ferry, Harwich.

96805

UNLOADING THE TRAIN FERRY

Although the train ferry cannot be seen, this steam engine is hauling off trucks which have arrived from Zeebrugge. The bridge equipment was brought to Harwich from Southampton by barge and tug, but met disaster near the Cork Lightship. What could be salvaged was, but a replacement tower and machinery had to be brought from Richborough. The three train ferries were simply numbered 1,2, and 3. There were four railway tracks on board which became two at the stern. The ferry could carry up to 50 ten ton rail trucks and two of the ferries were in constant use, sailing every day.

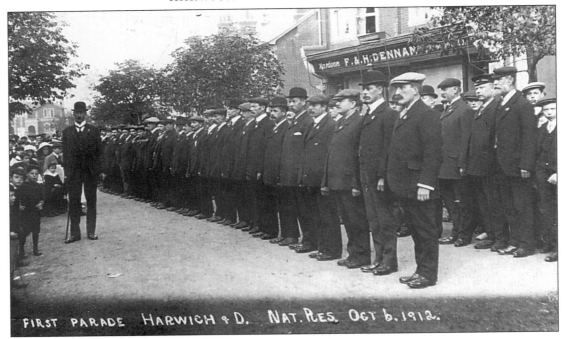

FIRST PARADE HARWICH & D. NAT. RES. OCT 6. 1912.

FIRST PARADE OF THE HARWICH & D NATIONAL RESERVE

Dovercourt Railway Station can be seen in the distance behind the trees, with Dennant's Fancy Store prominent in the background, selling traditional seaside gifts, postcards and crested china. This parade was under the command of Captain Tuffnell and consisted of about 110 men. They marched with the Church Lads Brigade Band and their own band, the Boy Scouts and the boys from Watts Naval Training School. St Nicholas Church was full to hear the Rev Telford sing the praises of those men (veterans of past campaigns and those with no experience) who had volunteered to fight, if required, for King, Country and Family. Following the service they returned to Station Road.

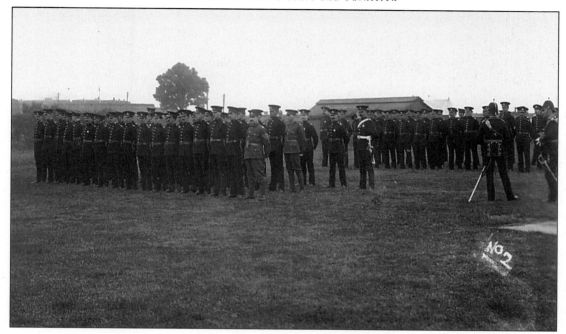

SOUTHEND AND STRATFORD VOLUNTEERS ON BARRACK FIELD

The Southend and Stratford Volunteers spent 15 days in July 1913 encamped on the Barrack Field for their annual camp. It was a relatively small group - 50 non-commissioned and 34 commissioned officers. They arrived by train and marched to the camp. For the traditional Sunday service they were joined by the Harwich National Reserve under bandleader J Coombe. After the service as can be seen here - they formed up on the cricket pitch for inspection by Colonel Buckle who was the officer commanding the Harwich division. The men practised gun drill at Harwich and Landguard, and their activities kept many locals entertained and many tradesmen in business.

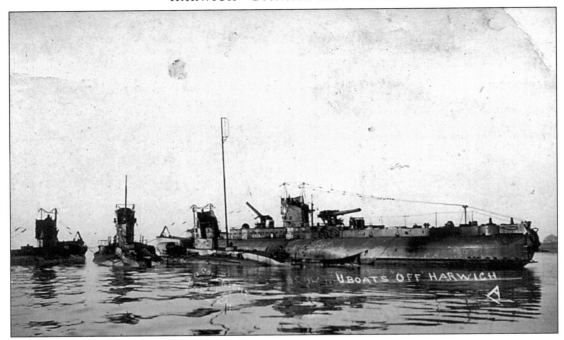

U-BOATS OFF HARWICH

There were many views published showing the surrender of the German Fleet at Harwich and one can visualise the photographers hiring small craft to take them up and down the river. Once the Armistice had been signed, the German U-boat fleet was commanded to sail to Harwich which had been an important naval base throughout the war. Cruisers, destroyers, minelayers and minesweepers had all frequented the harbour. When the hostilities ended, Admiral Tyrwhitt gave strict instructions that there was to be no intimidation of the defeated German fleet. Sailing silently into the harbour on a foggy morning, almost 150 submarines and a floating dock created an impressive sight and became known as "U-Boat Avenue".

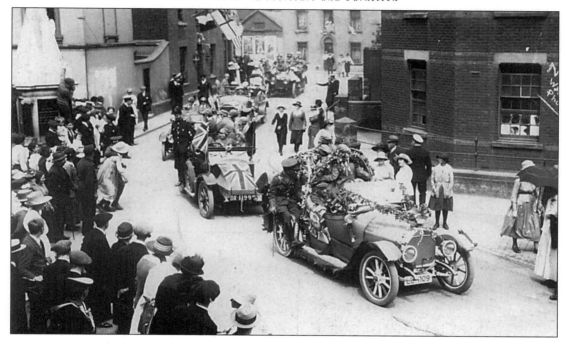

PEACE DAY PROCESSION, 24 JULY 1919

A procession emerging from Church Street into Wellington Road and then into West Street, as part of the Borough's Peace Day celebrations. The fountain is clearly visible and provided an excellent vantage point for younger spectators. The national day of thanksgiving began with a dinner for old age pensioners who were given a packet of tea (ladies) and a packet of tobacco (men). A procession then formed up and marched through the streets as shown above. Later, after the procession, 2350 children sat down for tea. The evening ended with a fancy dress and torchlight carnival procession.

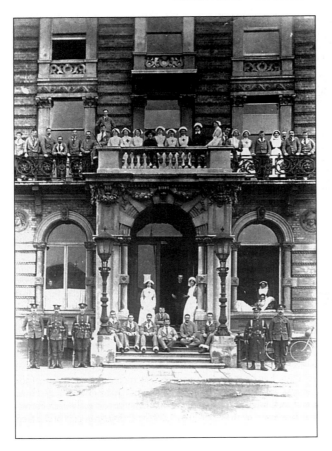

G E R HOTEL AS A MILITARY HOSPITAL

During the First World War, the G E R Hotel and its annexe were used as military hospitals. The Red Cross nurses under Mrs Brooks (wife of the local JP) and men of the Harwich Volunteer Aid Detachment (under Commandant Etherden) hastily prepared the Hotel for the reception of the wounded brought back from the Western Front. The men also provided the Armed Guard seen here for the first few months, until they were replaced by the Home Hospitals Reserve. The more seriously injured servicemen were taken straight to Shotley for treatment.

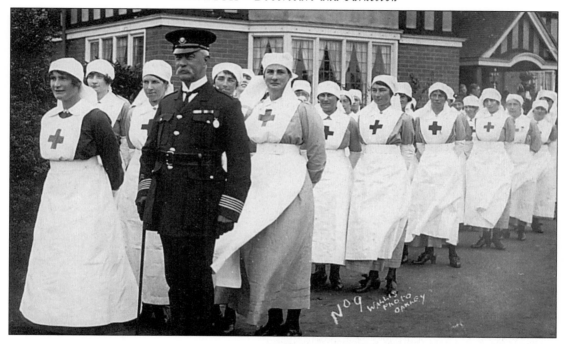

RED CROSS NURSES LEAVING THE GRANGE

The Grange, built as a private house in 1911 for Mr Hepworth, was one of many buildings taken over by the Government during the First World War as hospital or convalescent facilities. Here a group of nurses are leaving the front entrance of the Grange. Concerts seem to be part of the convalescence process and the men who spent Christmas 1914 in the GER Hotel were entertained by the nurses concert on Christmas Eve, and on Christmas Day were allowed to invite one guest each for tea. The Grange was owned by Miss Lilley in the 1920s and was purchased by the Council in 1939 for £5000, with part of the land used for a new fire station.

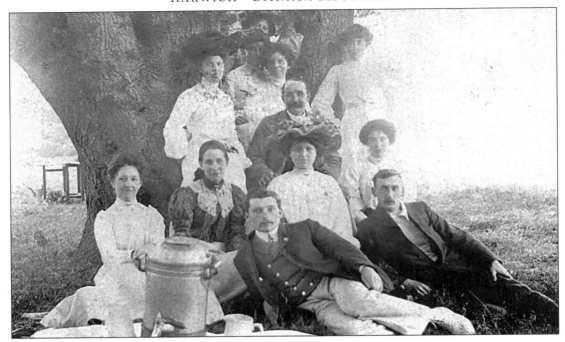

WESLEY GUILD PICNIC - SOCIAL COMMITTEE

This is one of two cards specially photographed and printed for the occasion; one dated the 8th July and the other the 9th July 1906. This was the time when excursions, trips and treats were popular for school children, Sunday school children, employees, social groups and committees. They took the opportunity to enjoy picnics, teas and games locally (e.g. Michaelstowe Hall, Dunn's Meadow) or went further afield to Wrabness, Thorpe or Clacton. This card reads, "Do you recognise anyone here? Last Wednesday we had our Wesley Guild Picnic. This small group is the Social Committee. Not bad for an amateur, is it? Annie."

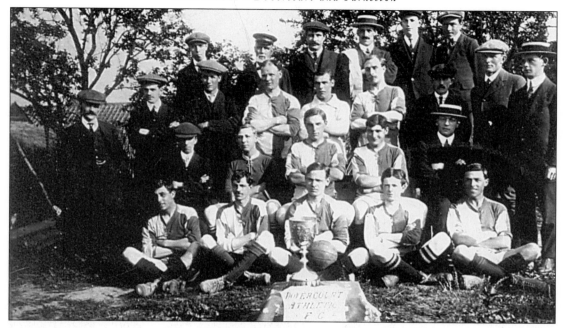

DOVERCOURT ATHLETIC FOOTBALL CLUB

1912-1913 was a momentous season for the players and committee of the Dovercourt Athletic Football Club, shown here proudly displaying the Harwich and District Football League Shield. The end of the season provided a thrilling finish when Harwich and Parkeston Reserves and Dovercourt Athletics finished equal on points. Harwich and Parkeston won a play-off by 3 goals to 2 on Dovercourt's home ground in Upper Dovercourt. Having seen Harwich presented with the trophy and medals, Dovercourt lodged a complaint with the League Committee concerning a match against Walton where Harwich had been awarded points although the game had not been played. The appeal was upheld and the Athletic players were awarded the shield and medals instead.

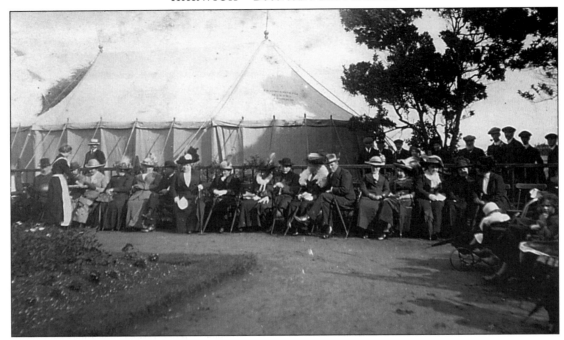

MAYOR'S GARDEN PARTY, DOVERCOURT PARK 7 MAY, 1913

On the occasion of the Mayor's annual garden party - the Mayor and Mayoress 'At Home', 300-400 guests enjoyed the hospitality of Alderman W McLearon and his wife in Cliff Park. They greeted their guests at the entrance to the enclosure where they were offered tea. The entertainment for the first concert of the new season was provided by the Corporation Band conducted by Mr. W Crosby. Miss Emily Crosby, Mrs Ford and Mr H Wright also performed and were apparently much appreciated by the guests.

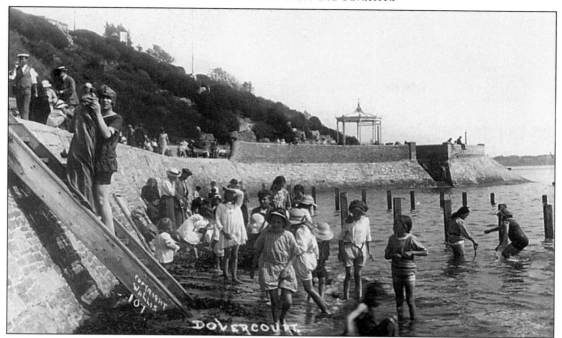

CHILDREN ON THE BEACH, DOVERCOURT

There seems to be no end to the variety of cards produced by the Wallis photographers. This is one of the better views of children playing on the beach at Dovercourt. By now, the etiquette requiring judicious use of bathing machines and full cover of the body had gone. Adults still maintained an air of formality but the children delighted in paddling and swimming in the sea and also seemed to take great delight in posing for the camera. Note the absence of any hand rails on the steps down to the beach and any protection from the drop below the edge of the promenade.

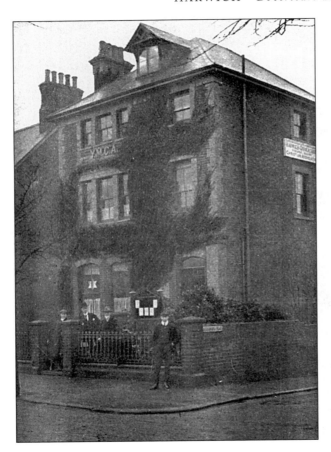

YMCA, SEA VIEW, DOVERCOURT

The local YMCA was founded in July 1887 and based at the local Mission Hall where devotional meetings, bible classes and lectures were held. A library and reading room were established and later the YMCA held social gatherings, athletic and gymnastic events including an Annual Sports Day on the Royal Oak Meadow. They purchased the three-storeyed "Sea View" in July 1904 with its 3 reception rooms, 5 bedrooms, hall and kitchen. The card reads, "This is the YMCA. It isn't a bad building is it? The chap on the right is our president, the one in the centre is the secretary and the chap standing on the path is the assistant secretary".

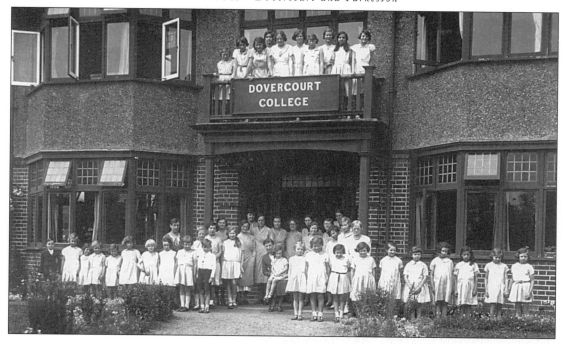

DOVERCOURT COLLEGE

Dovercourt College was one of many private schools set up locally before the 1944 Education Act. This view of the pupils from the College shows that it was predominantly a girls school, although there are 2 boys posing for the camera in the 1920s when Miss Main was Principal. There were also private schools in Orwell Terrace and Cliff Road. In 1888 J Wickham Towser had his Dovercourt High School for Boys at number 9 Orwell Terrace with "ample accommodation for large numbers of boarders". There was also the Convent School at the top of Orwell Terrace run by the sisters of the Convent of Mary Help for Christians.

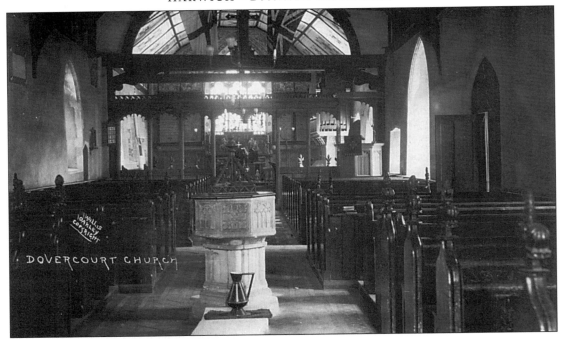

DOVERCOURT CHURCH

The initial growth of Dovercourt was in and around All Saints parish church, Upper Dovercourt. The church has been described as "an edifice of brick and rubble" possibly dating from the 11th or 12th centuries. It was given as an endowment to a cell formed by monks taken from Abingdon "to serve God by the Colne" who lived in the cottages opposite the church. The nave is probably 12th century and the chancel 14th century. The West Tower was built c1400. The font, shown above, and dated 14th century, was found in a local farmyard being used as a cattle trough before being returned to the church. There is a poor box dated 1589 and the lych gate was a gift from Queen Victoria.

GREAT WAR MEMORIAL, UPPER DOVERCOURT

The Upper Dovercourt War memorial was unveiled on 7 August, 1920 by the Lord Lieutenant of Essex, in memory of those men who lost their lives in the Great War. Looking from Fronks Road towards the memorial, the house in the left background is Pound Farm House, built in the 18th century and owned by Joseph Gant. Development was just starting in Upper Dovercourt at this time. Just a little further along, Vine Terrace had been built in 1911, Clarkes Farm and farmhouse occupied the site on the other side of the Church (where Vacuumatic was later to be built), and The White Horse and the Church of England School had also been built at this time.

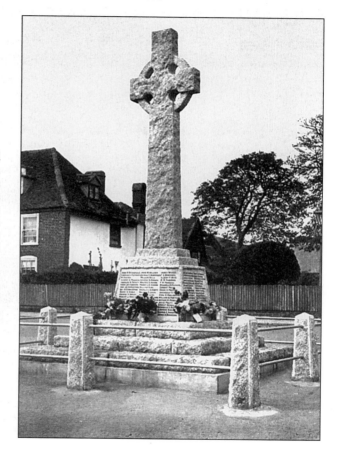

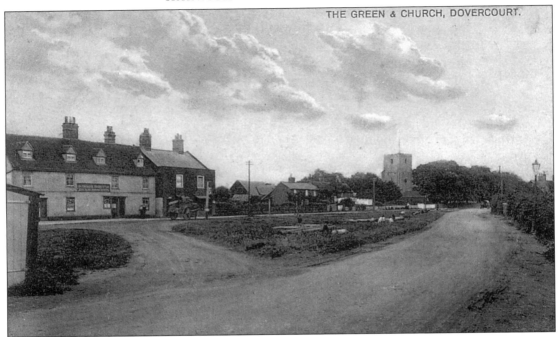

THE GREEN & CHURCH, DOVERCOURT.

THE GREEN AND CHURCH, UPPER DOVERCOURT

Upper Dovercourt at the turn of the century showing few houses and fewer shops. The Domesday Book described the area as Upper Dovercourt; Harwich came later and Dovercourt developed in the mid 1800s. It was thinly populated with farms, farmhouses and cottages. There was very little traffic but had a well worn path to the Trafalgar public house. The Bird in Hand is just out of shot, but offered a third public house within a few hundred yards. Mr Curle had a shop next to the Trafalgar and the Wesleyan Church had been built on the other side in 1866. As you headed towards Tollgate, housing became more sparse and fields and farms predominated through to Ramsey and Little Oakley.

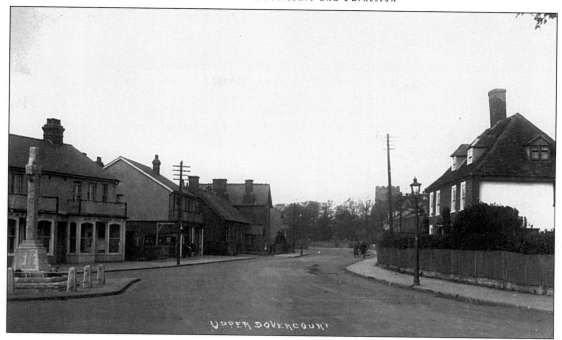

UPPER DOVERCOURT

Another Wallis view, this time showing Upper Dovercourt in the early 1920s. Pound Farm House dominates on the right, but on the left shops had been built in response to the growing number of houses being built in the area. From the memorial, the first shop of the pair was the butchers belonging to A P Lilley and next door was the fishmongers, at this time F Tollady. The entrance to Crawley's Garage can be seen and the two shops next door belonged to Mr Bailey the bootmaker and F C Jeans, fruiterer. The Infants School and School House came next, and another shop before the White Horse.

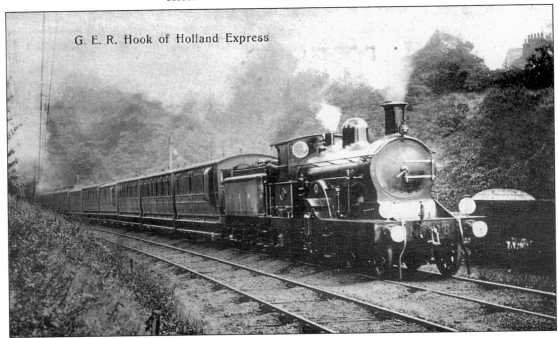

G. E. R. Hook of Holland Express

G E R HOOK OF HOLLAND EXPRESS

Boat trains have been a feature of the shipping service from Parkeston Quay for well over 120 years, interrupted only by two World Wars and the 1953 flood. Not only were the services developed from Liverpool Street but a joint GE/GN line in 1882 opened up Parkeston Quay to the north and Midlands. Initially the trains met connections at Ely, but within 13 years linked up with York - one of the first cross-country expresses. The LNER operated the Hook Continental in the 1920s and, as Scandinavian services and the Zeeland Steamship Company developed, a "Scandinavian Express" and the "Flushing Continental" were operated.